Musical Instruments
from the
Renaissance
to the 19th century

Musical Instruments

from the
Renaissance
to the 19th century

Sergio Paganelli

HAMLYN

Translated by Anthony Rhodes from the Italian original

Gli strumenti musicali nell 'arte

© *1966 Fratelli Fabbri Editori, Milan*

This edition © *1970*
THE HAMLYN PUBLISHING GROUP LIMITED
LONDON · NEW YORK · SYDNEY · TORONTO
Hamlyn House, Feltham, Middlesex, England

SBN 600359204

Text filmset by Filmtype Services, Scarborough, England

Printed in Italy by Fratelli Fabbri Editori, Milan

Bound in Scotland by Hunter and Foulis Ltd., Edinburgh

Contents

	Page
Introduction	7
The Organ	24
The Harpsichord	71
Spinet, Virginals, Clavichord	79
The Pianoforte	80
Bowed Instruments	105
The Violin	112
The Viols	114
The Cittern	122
The Psaltery	123
The Lute	129
Guitar and Harp	132
Flutes	138
Horn Trumpet and Trombone	140
The Modern Revival	146
List of Illustrations	154

INTRODUCTION

Among the many arts of man practised throughout
the ages, from the greatest of all, speech, to the
figurative arts, painting and architecture, not the
least in interest, as in complexity, is the art of the
musical instrument.

This book is concerned not only with the particular
musical or technical function of each instrument but
also with its external or aesthetic aspect, for in almost
every case, the craftsmen, however functionally
minded, aimed to create something pleasing to the
eye. Even in modern terms, words like 'practical' or
'functional' are really synonymous with 'aesthetic' or
'beautiful'. If this approach to musical instruments is
reprehensible – a kind of visual hedonism – it can be
argued that such phrases as 'a pleasure to the eye' are
almost mechanically uttered by most people who look
at these instruments. However, I shall not neglect the
function of each instrument so that the reader will
better understand why the embellishment of some-
thing intended originally only to vibrate or emit sound

has invariably been undertaken. It is not too far-fetched to say that what the brush, palette and paint are to the painter, or the chisel, hammer and marble to the sculptor, or pen and paper to the writer, the musical instrument is to the composer.

Music is a vast subject if we consider it chronologically from the earliest times down to the present day. The first instrument to emit artificial sounds (using the adjective in its original sense) was the human voice; only much later were man's vocal chords supplemented by instruments that he himself created. In an important work of research on the subject, the term 'implements or tools of music' is used, and it is most apposite. The world of musical instruments is like a vast laboratory in which all the 'implements' or 'tools' are employed in a universal language with a grammar, syntax and vocabulary capable of unlimited development. Its complexity renders it the most artificial human means of communication, but it is also among the most pleasurable of these means, able not only to delight and stimulate intellectually, but to play on the whole gamut of human emotion.

The instruments are the words in this universal language, many of them going far back into antiquity, Oriental and European; even the names of some are unknown. Each instrument's history and evolution has been traced and examples of each stage of its

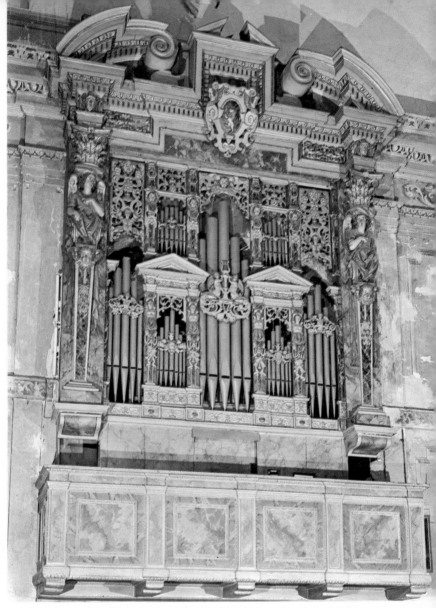

1 Organ by the Antegnati family. Third decade of the 17th century. S. Carlo, Brescia.

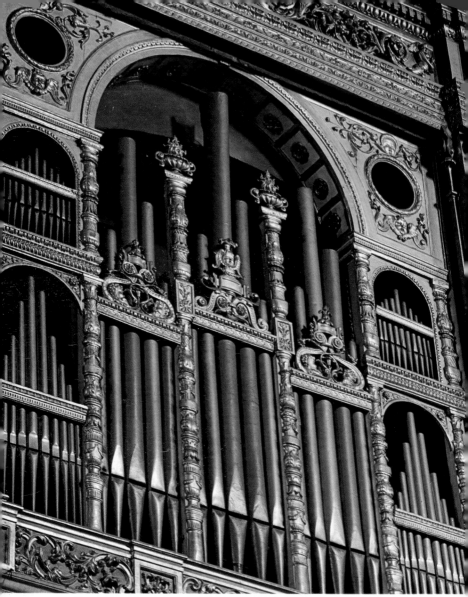

2 Organ by Domenico di Lorenzo of Lucca. 1523. SS. Annunziata, Florence.

development displayed in museums. At some point in that development, an instrument falls into the hands of a composer who writes for it and plays upon it with such skill that it achieves its full stature.

The following letter from an erudite literary man of the mid 16th century gives some idea of the extent of the subject, as well as of the aesthetic aspect of musical instruments. 'I know that sometime you will have to deal with those rich and cultivated *signori* who delight in adorning their palaces and houses, their rooms and libraries, with many and varied ornaments. Some employ musical instruments, organs, harpsichords, psalteries, harps, clavichords and similar instruments; others use lutes, viols, violones, lyres, flutes, cornetts, tibias (ancient flutes), bagpipes, trombones and other such instruments – a habit to be much commended, for thereby they delight the ears and hearts of many. Equally agreeable are these instruments to the eye, when made by the finest master. . . .'

Classification

The classification of musical instruments made by Curt Sachs is now commonly accepted as the most logical form of grouping; it is a good starting-point for examining such a variety of instruments.

1 Organ by the Antegnati family. Third decade of the 17th century. S. Carlo, Brescia. This was certainly made by the Antegnati; probably designed by Costanzo, who died in 1624, and completed by his son, Graziadio. The entablature is supported by two caryatids, and the richness of its 17th-century inlays – although rendered too heavy by mediocre polychrome – makes it the decorative focus of the church. In addition to the normal full diapason, it has two flutes and a vox humana.

2 Organ by Domenico di Lorenzo of Lucca. 1523. SS Annunziata, Florence. The thin candelabra pillars that divide the case into five sections are still in the 15th-century taste, and the deep central arch dominates the ensemble. The pipes in the upper sections are purely decorative. The elegant wooden case with its gilded carving on an ivory background is the work of Giovanni d'Alesso, known as Nanni Unghero.

3 Organ by Giangiacomo Antegnati. 1536. Rotonda, Brescia. Note the elegant architecture and richness of the carved inlays, the work of an unknown artisan but clearly echoing contemporary Lombard sculpture. The instrument underwent an acoustic revision by the Serassi in 1826, but the pipes of the façade and most of the interior ones are original.

4 Positive organ by Gottfried Silbermann. 1724. Karl-Marx-Universität, Leipzig. Originally in a church in Hilbersdorf, near Freiberg, this organ was attached to the parapet of the organ-loft, in front of the main organ (no longer preserved), and behind the organist.

3 Organ by Giangiacomo Antegnati. 1536. Rotonda, Brescia.

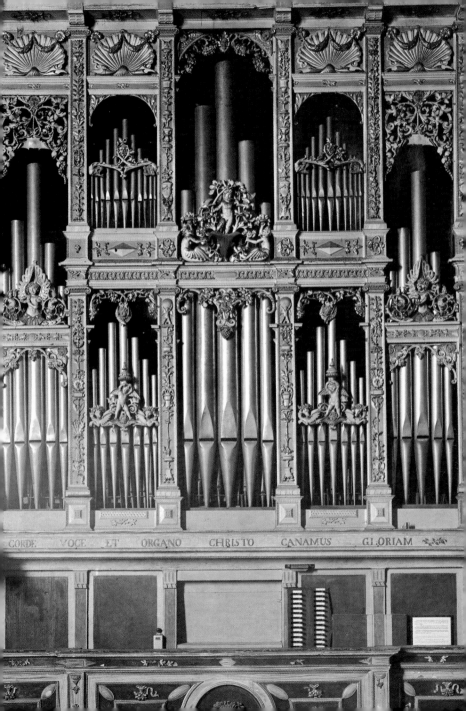

CORDE VOCE ET ORGANO CHRISTO CANAMUS GLORIAM

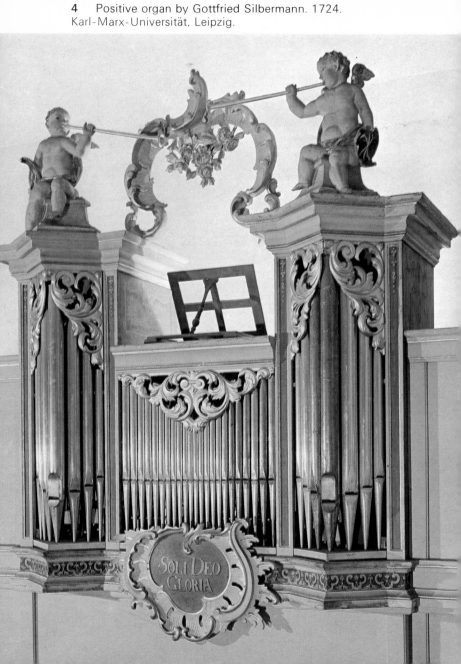

Sachs places them in four groups:

First, the idiophones, in which the sound is produced by the vibrations of a body. This group is in turn subdivided according to the cause of the vibration, whether percussion or friction. Of this class the best known examples are cymbals, castanets, the triangle, the xylophone and gongs.

Second, the membranophones, in which the sound is produced by the vibration of a membrane or stretched skin: kettledrums and other types of drum.

Third, the chordophones, in which the sound is produced by the vibration of strings. This category too is subdivided. There are the instruments plucked by the fingers or a plectrum, including the cithern family, the psaltery, the harp, the lute and the guitar. Then comes the mechanical plucking of strings, as in the harpsichord, the spinet and the virginals. In the clavichord and pianoforte the strings are struck with hammers (or tangents, in the case of the clavichord) operated by the keys. If vibration is caused on the strings by the friction of another object, such as a bow drawn across them, we have what is known as the 'strings' – including all the viols, of various shapes and sizes, and the family of violins, which today includes the modern viola, cello and double-bass.

Fourth and last, the aerophones, in which sound is produced by the vibration of air passing into a tube

through a mouth-hole, as in the flute family. This category includes the 'brass section' (trumpets, cornets, etc.), in which the vibrations are governed by the movement of the human lips, which also determine the pressure of the air vibrating in the instrument. There is also the family of reed instruments, in which the vibrations are produced by a reed, or a small thin piece of wood or metal placed at the mouthpiece: the single reed (the clarinet), or the double reed (the oboe).

These classifications have been simplified as far as possible, since we cannot study every instrument. They are convenient to use in studying the history of instruments, making it possible to appreciate the connections between instruments produced in different periods and cultures, including technical and structural qualities. Establishing such connections is important, because often nothing is known about an instrument beyond its appearance, recorded in a fresco or manuscript. Sometimes the instrument is found to have come down the centuries almost unchanged. Instruments often share a common origin, and we shall be examining the outstanding examples.

Something akin to a genealogical tree can be constructed for many instruments, which have changed over a period of time, in shape as well as in function, construction and the way in which they produce

sound. The laws of acoustics were at first only sur-
mised, but as they became scientifically defined, they
directly influenced the shape and component parts of
instruments. Hence the methodical classification to
which we have referred is not merely theoretical;
much of it can be verified in concrete form.

Each group of instruments has its own tradition, in
which the methods of construction have been handed
down from one instrument-maker to another; or
sometimes skilled artisans have faithfully copied an
existing model. Each instrument is made from a
particular material. The woods best suited to wind or
stringed instruments are spruce, maple, beech and
willow, all carefully seasoned. The catgut or metal
strings have to be the right length and thickness in
relation to the desired sound, which depends too on
whether they are plucked with the fingers or with a
plectrum, or bowed. Wind instruments have either a
conical or cylindrical cavity, a regulated diameter, and
holes placed at carefully measured intervals. Every
instrument is constructed according to a fixed code of
laws, which permits variations in the proportions and
individual parts, but only within strictly defined limits.
There is a clear functional relationship between the
instrument and the acoustic factors which originally
determined its shape, although sometimes for technical
or traditional reasons variations were permitted.

5 Organ. 17th century. New Cathedral, Salamanca. One of the finest organs in Spain, with profuse decoration, rich inlays and imaginative arrangement of its many non-speaking pipes. A peculiarity of these Spanish instruments are the pipes of a reed stop (usually a trumpet) set horizontally outside the case, above the organist, to increase the volume.

6 Italian portative organ. 1608. Conservatoire Royal de Musique, Brussels. This elegant instrument, with its geometrical ribboning and carved ivory panels, is one of the old-fashioned organs which could be carried and played by the same person, as seen in the right-hand panel.

7 Positive organ. First half of the 18th century. Castello Sforzesco, Milan. In spite of the modest decoration of the case, with its architectural *trompe l'oeil*, it is aesthetically pleasing. The wooden pipes of the façade — a frequent feature of small organs — should be noted.

8 Positive organ by Hähnel, *c.* 1725. Schloss Pillnitz (Wasserpalais), Dresden. Organs—particularly chamber organs — did not escape the popular taste for lacquer. This is a work by the German cabinet-maker Martin Schnell, who cleverly adapted the original Classical case to the Oriental fashion.

5 17th-century organ. New Cathedral Salamanca.

6 Italian portative organ. 1608. Conservatoire Royal de Musique, Brussels.

7 Positive organ. First half of the 18th century. Castello
Sforzesco, Milan.

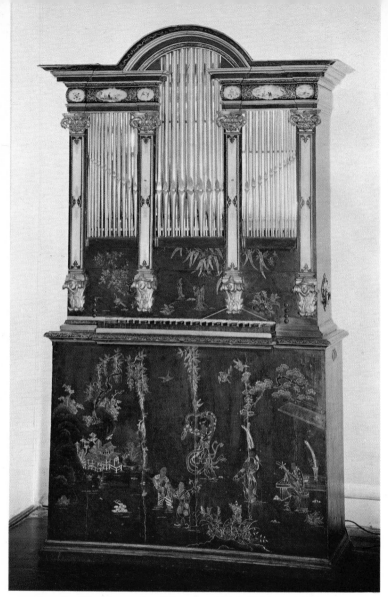

8 Positive organ by Hähnel, *c.*1725. Schloss Pillnitz
(Wasserpalais), Dresden.

Variations of shape and embellishment had to be subordinated to these technical requirements, but there were always some opportunities for craftsmen to exercise their decorative talents. From early times, instruments were decorated with carvings, painted motifs, inlays and gilding, sometimes in a baroque profusion.

Only the stringed instruments, in particular the violin, have a beauty which is purely functional. It is impossible to alter their proportions, the length of the neck, the thickness of the wood or the shape of the instrument. A violin created by a great master is so graceful that carving or inlay would only mar its beauty.

As I have pointed out, the function of an instrument did not preclude the decoration of those elements which were not directly concerned with the production of sound. In stringed instruments, for instance, the end of the neck, known as the scroll, could be carved in various ways without impairing the tone. In lutes and related stringed instruments, the circular sound-hole on the belly of the case could be either pierced and carved or inlaid with geometrical patterns in multi-coloured woods, and the neck and back inlaid with mother of pearl. Wooden wind

instruments, such as flutes, could be carved. Even the earliest trumpets are decorated with carved animals' heads or geometrical patterns in relief. With keyboard instruments, such as the harpsichord, the virginals, and small positive organs, the artist had much greater scope, decorating the base with carving, and the case, lid and outside parts – not involved in sound production – with painted motifs. Sometimes these instruments were made to resemble pieces of furniture – a chest or a magic box which, to the surprise and delight of the guests, the host would open and play.

It is now appropriate to examine particular instruments a little more closely, and describe their characteristic qualities. Quite arbitrarily, I have chosen to consider first those instruments in which the decorative arts can be most freely applied, and then those where strict acoustic rules alone determine the appearance.

THE ORGAN

Keyboard instruments come first on this list, for they can be freely decorated without affecting sound production. The organ is the most complex of these, both in its appearance and in its internal mechanism, incorporating devices no less precise than those which

operate the jacks of a harpsichord or the felt-covered hammers of a piano. The organ, more than any other musical instrument, offers complete liberty to the imagination of the designer and builder, and is potentially the centrepiece of a complete decorative scheme. Without impairing its tonal quality, an organ can become a part of any background or surroundings, from the dignified beauty of a Renaissance room to a modern concert hall. Almost all other instruments reach a culminating point in their development and remain fixed, without any substantial modifications being made, whereas the organ has been adapted to the requirements of every century. In attempting to imitate the instruments of the orchestra in the organ, builders have sometimes overreached themselves, but generally speaking the almost limitless adaptability of the instrument has made possible a satisfactory result.

The organ has always been popular in Europe, although its form and appearance have varied greatly over the centuries, and from country to country.

Mechanically, the organ is simple enough. Artificially produced wind under a regulated pressure is applied to pipes, causing the column of air they contain to vibrate and emit sound; all wind instruments work on this principle. The apparatus that provides the wind is the organ-bellows. Although this can be

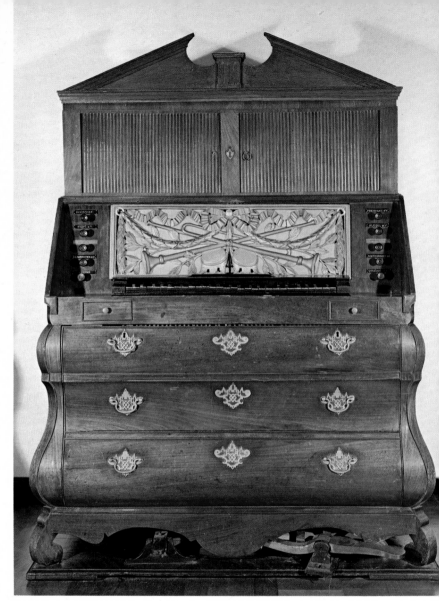

9 Dutch positive organ, *c.*1770. Gemeentemuseum, The Hague.

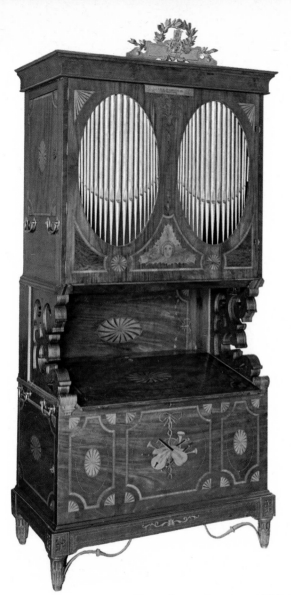

10 Positive organ by Diego Evans. London, 1762. Museo
Municipal de Música, Barcelona.

9 Dutch positive organ, *c*. 1770. Gemeentemuseum, The Hague. In small chamber organs the mechanism was often concealed in what appeared to be a piece of furniture. This particular instrument was designed as a small commode. It is a typical example of elegant mid 18th-century Dutch taste.

10 Positive organ by Diego Evans. London, 1762. Museo Municipal de Música, Barcelona. Designed like a cupboard. This fine case, with its simple lines and sober decoration, would harmonise admirably with almost any interior of its period.

11 Regal. Probably Italian. 1739. Museo Municipal de Música, Barcelona. Built as a small cabinet. This organ is of Florentine origin, of a type popular in the 16th century. A row of keys is revealed when the doors are opened, and the architectural centre-piece, surrounded by imitation drawers, conceals the reeds.

11 Regal. Probably Italian. 1739. Museo Municipal de Música, Barcelona.

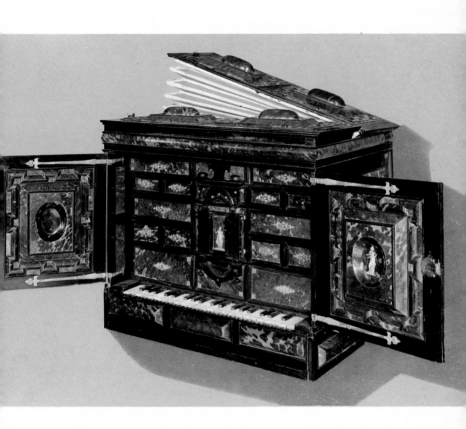

operated manually, electricity is now normally employed. The quality of the sound depends to a considerable extent on the air pressure, which is regulated by weights.

The machinery by which the player makes the pipes 'speak' is invisible. By depressing a key, a series of levers and metal wires is set in motion which opens a valve in the wind-chest. The wind-chest is a large rectangular wooden case, extending across the entire organ, on which the pipes are placed; wind is pumped into it from the bellows, and it has a series of valves, each of which is operated by a key. Between the wind-chest and the pipes is a series of sliding wooden strips which open and shut the pipes. These are the stops, worked by levers placed beside the keyboard. Beside and above this complicated mechanism, developed and perfected over the centuries, rise the gleaming metal pipes and the decorated case.

Most of the speaking pipes are concealed behind those on the organ case. These external pipes, placed according to length and diameter in two or more symmetrical groups, are extremely decorative. The same may be said of the geometrically designed feet (the parts which support the pipes, in the shape of an inverted cone, ending in horizontal openings, the mouths, which produce the sound), which are of varying heights. The pipes are of tin, lead, an alloy of

the two metals, or sometimes wood. They are divided into two groups: flues when the vibrations are produced by the mouth; reeds when the sound is produced by the vibration of a reed inside the unit, amplified by the cone-shaped pipe. In the first group, the pitch of the note is determined by the length of the pipe: the longer the pipe, the less frequent the vibrations and the lower the note. In the reeds, however, the note is determined by the length of the reed itself, which is concealed in the foot and amplified by the pipe. The length of the pipes, traditionally measured in feet, varies from thirty-two feet to a few inches.

The organ has a larger range of sounds than any other instrument. If the length of the pipe determines the pitch of the note, the quality of the material, the diameter and shape of the pipe and the cut of the mouth govern the colour and quality of the sound. After centuries of experiment, certain combinations of pipes were formed, linked by the same sound or timbre; and these are called stops.

These stops, groups of pipes that correspond to the entire range of the keyboard, became known as basic stops, mutation stops (with flue pipes) and reed stops. They are normally designated by the length of the pipes emitting the lower notes: eight feet, where the register produces a sound corresponding to the written note and covers the normal range of the

human voice; sixteen or thirty-two feet, where the note is one or two octaves lower; and four, two or one feet, where the note is one, two or three octaves higher. The subdivisions of the basic stops are distinguished by their tone and special instrumental flavour. First comes the diapason, the fundamental tone of the instrument, whose pipes are on the front; then the 'flute', with stops of a larger diameter than those of the diapason, with a rounder and sweeter tone that is in fact reminiscent of a flute; then the Bourdon pipes, the upper parts of which are stopped, thus producing notes an octave lower. All the stops of these subdivisions can be from thirty-two down to two feet in length.

The mutation stops are the most brilliant on the organ. They enrich the harmonics (the sounds which can be heard above the fundamental, adding higher notes of a fifth, a third, an octave, etc.). Among these, and related to the families of the flute and diapason on account of the ratio between the diameter and the height of the pipe, the twelfth (similar to the nazard) should be mentioned. The cornett and the sesqui-altera also belong rather to the composite mutation stops, as they are composed of more than one row of pipes playing at the same time.

The full diapason, with its five or six independent rows faithfully reproducing the successive harmonics

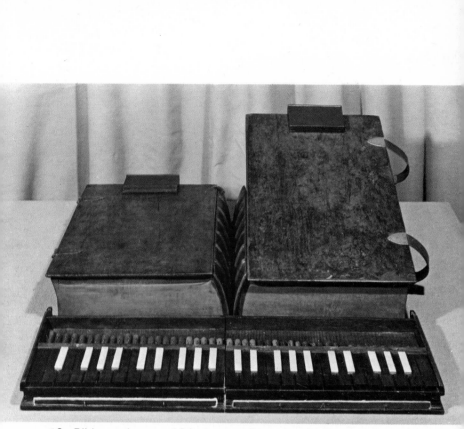

12 Bible regal organ. 18th century. Conservatoire Royal de Musique, Brussels.

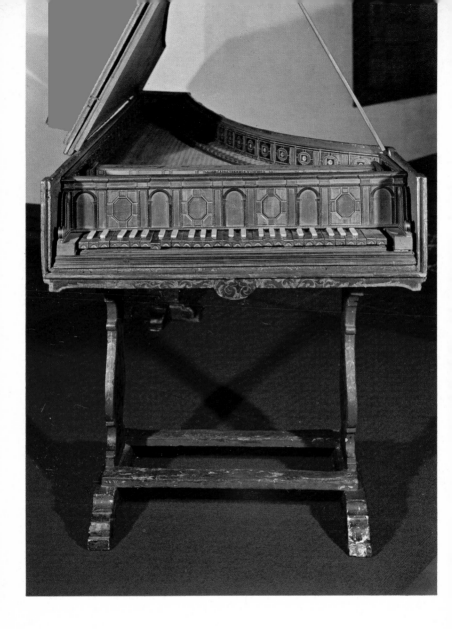

13-14 Harpsichord by Vito Trasuntino. 1571. Castello
Sforzesco, Milan.

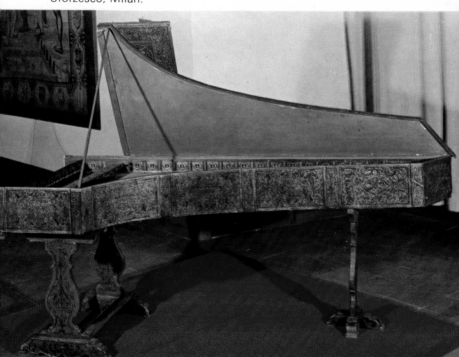

12 Bible regal organ. 18th century. Conservatoire Royal de Musique, Brussels. The taste for disguising an instrument sometimes took the form, with pleasing effect, of imitating the covers and spines of books. Hence this kind of regal (an organ with a reed stop). Particularly popular in Bavaria.

13–14 Harpsichord by Vito Trasuntino. 1571. Castello Sforzesco, Milan. As can be seen in plate 13, the instrument itself is in a case with a lid. The furniture-maker's work, with high relief and geometrical inlays in precious woods above the keyboard, as well as inside the case, is remarkable. The elegant proportions and decoration are characteristic of the Italian harpsichord.

15 Two-manual harpsichord by Hans Ruckers. 1612. Conservatoire Royal de Musique, Brussels. There are hunting scenes set in panoramic Flemish landscapes (clearly the work of a skilled artist) on the lid and sides. This instrument, with its powerful tone and two manuals, is massive and solidly constructed.

15 Two-manual harpsichord by Hans Ruckers. 1612. Conservatoire Royal de Musique, Brussels.

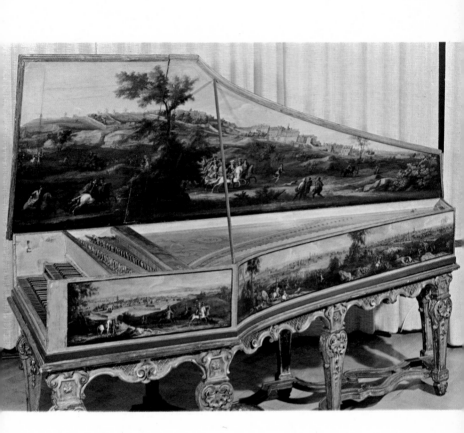

THE FOUR MAIN GROUPS OF MUSICAL INSTRUMENTS

I. IDIOPHONES

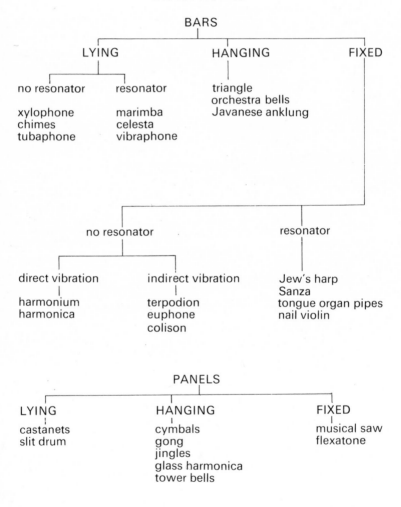

BARS

LYING | HANGING | FIXED

LYING
no resonator | resonator

xylophone | marimba
chimes | celesta
tubaphone | vibraphone

HANGING
triangle
orchestra bells
Javanese anklung

no resonator | resonator

direct vibration | indirect vibration

harmonium | terpodion
harmonica | euphone
| colison

Jew's harp
Sanza
tongue organ pipes
nail violin

PANELS

LYING | HANGING | FIXED
castanets | cymbals | musical saw
slit drum | gong | flexatone
| jingles
| glass harmonica
| tower bells

II. MEMBRANOPHONES

DIRECT VIBRATION

tuned	untuned
kettledrum	bass drum
	side drum
	tenor drum
	tabor drum
	tambourine

INDIRECT VIBRATION

mirliton

III. CHORDOPHONES

PLUCKED WITH THE FINGERS

no fingerboard	fingerboard
harp	lute
	chittarone
	theorbo
	colascione
	guitar

PLUCKED WITH A PLECTRUM

no fingerboard	fingerboard	keyboard
lyre	mandoline	harpsichord
psaltery	zither	spinet
cittern	balalaika	virginals
	banjo	

BOWED

rebec
fiddle
viol
viola da-gamba
violin
viola
'cello
double bass
bowed zither
philomela
bowed melodion

STRUCK

no keyboard	keyboard
dulcimer	clavichord
tambourin de Béarn	pianoforte

RUBBED

hurdy-gurdy

IV. AEROPHONES

LIPS RIDGE

no groove	groove
pan-pipes	lip organ pipes
transverse flute	recorder
näy flute	chakan
	pipes (folk)

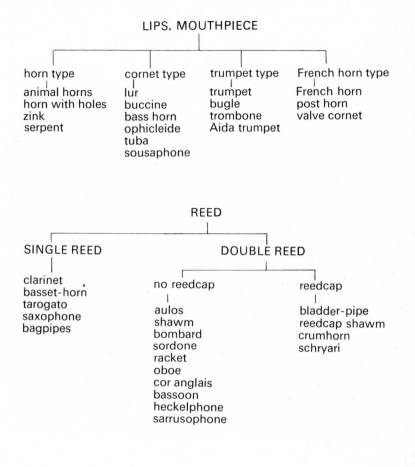

LIPS, MOUTHPIECE

horn type	cornet type	trumpet type	French horn type
animal horns	lur	trumpet	French horn
horn with holes	buccine	bugle	post horn
zink	bass horn	trombone	valve cornet
serpent	ophicleide	Aida trumpet	
	tuba		
	sousaphone		

REED

SINGLE REED | DOUBLE REED

clarinet
basset-horn
tarogato
saxophone
bagpipes

no reedcap

aulos
shawm
bombard
sordone
racket
oboe
cor anglais
bassoon
heckelphone
sarrusophone

reedcap

bladder-pipe
reedcap shawm
crumhorn
schryari

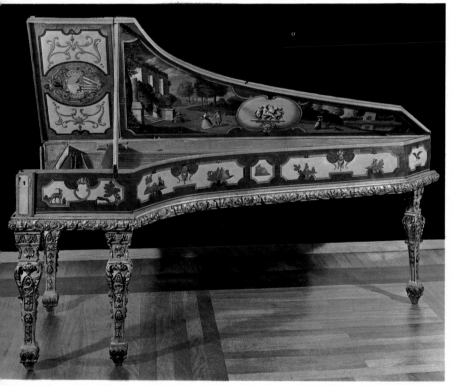

16 Single-manual harpsichord by Giovanni de'Perticis.
Florentine. 1672. Gemeentemuseum, The Hague.

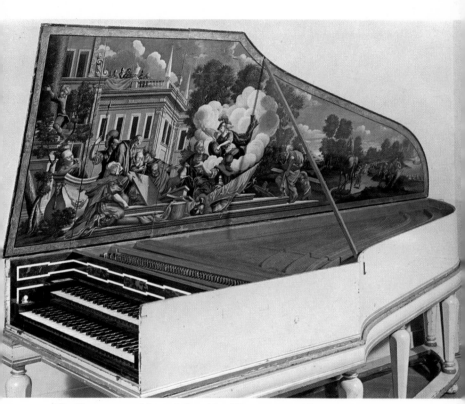

17 Two-manual harpsichord by Hieronymus Albrecht Hass.
1734. Conservatoire Royal de Musique, Brussels.

16 Single-manual harpsichord by Giovanni de'Perticis. Florentine. 1672. Gemeentemuseum, The Hague. This rare instrument is one of the few by this famous maker which survives. The legs and cornice of the stand, in carved and gilded wood, are perhaps a little too heavy for the instrument itself. Notice the painted case and the landscape inside the lid.

17 Two-manual harpsichord by Hieronymus Albrecht Hass. 1734. Conservatoire Royal de Musique, Brussels. An instrument made by the elder of the two Hasses, with the inscription 'Hieronymus Albre Hass fecit Hamburg, Anno 1734'. Note the manuals: the lower keys are of ivory, while the upper ones are inlaid with mother of pearl and tortoiseshell. The same materials are used on the sides of the case surrounding the manuals. A mythological subject is painted on the inside of the lid.

18 Single-manual harpsichord by Antonio Scotti. Milan. 1753. Castello Sforzesco, Milan. This instrument, on which Mozart composed his opera Mithridates, is valuable from both an historical and a technical point of view. Notice the luxuriant decoration of the ebony keys, each inlaid with the name of the note, and the façade with incrustations of mother of pearl and precious wood.

19 Two-manual harpsichord by Piero Todino. 1675. Castello Sforzesco, Milan. Italian two-manual harpsichords are rather uncommon, and those by Todino particularly so. The colour of the cypress-wood case is enhanced by decorative motifs on a russet background. A harbour scene is painted inside the lid. On the outside are the arms of the Colonna family.

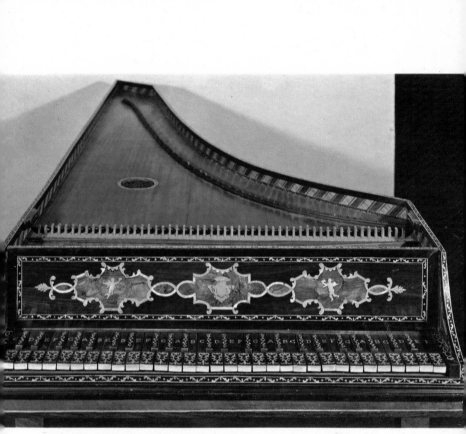

18 Single-manual harpsichord by Antonio Scotti. Milan.
1753. Castello Sforzesco, Milan.

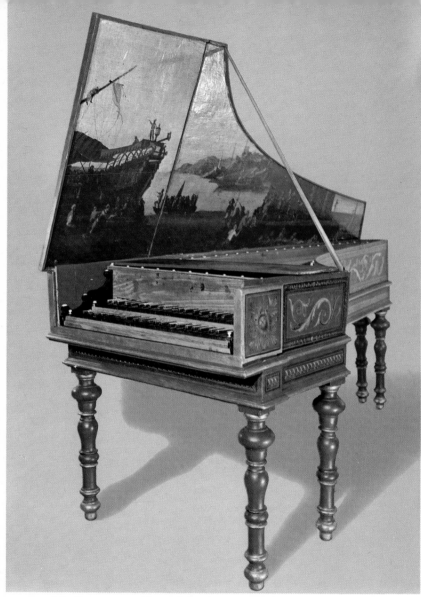

19 Two-manual harpsichord by Piero Todino. 1675.
Castello Sforzesco, Milan.

of octaves and fifths of the fundamental, may be considered an example of a composite mutation. Another group of stops producing a fine variety of effects are the reeds, containing the trumpet, the oboe and the crumhorn. The control panel of stops for the selection of timbres, operated by a series of levers and connecting rods, is beside and above the manuals, two or three keyboards which further increase the possible number of permutations. Below the manuals is the pedal board, a set of pedals operated by the feet, which correspond to a series of notes in the lower registers. This apparatus, present in early 16th-century Italian organs, was greatly developed in Germany from the 17th century onwards, allowing the player new possibilities for interplay with the manuals.

This is only an outline of the way in which an organ works. Even in its simplest form it is a complicated instrument, and its actual mode of functioning varied from region to region and century to century. An instrument of great antiquity – which even boasts a mythological inventor, Ctesibius of Alexandria, in the 2nd century BC – the organ was known to the Romans as a *hydraulus* because the wind pressure was produced by water. There is also a tradition that it was in use in the Middle East, particularly in Byzantium,

through which it came to Europe in about the 8th century. That it was popular in the Middle Ages and used in the Church liturgy is attested by literary and pictorial evidence, which records two types of organ, the portative and the positive. The first was so called because it was small and could be carried by the player; the left hand operated the bellows and the right the manual. The second was larger, but could be easily moved from one place and set up in another. Owing to its practical advantages, the positive organ continued to be constructed up to the 19th century. Another type of organ which must be mentioned, and of which several examples have survived, is the regal, in which the body was initially composed only of small reed pipes, endowing it with the practical advantages of the other two.

In Italy, by the 15th century, the organ was quite highly developed. It had a lower register, called the principal, and above this the ranks were distinguished by numerals corresponding to the harmonics, i.e. Octave, 15th, 19th, 22nd, 26th, etc., each constituting independent stops and forming together the full diapason. Next were the solo stops, the flutes, at the octave and twelfth, and the highly individual vox humana, a stop belonging to the family of the principal and in unison with it but slightly out of tune in order to produce the tremulant. The family of these last stops

was gradually enlarged, to meet the need for a larger tonal range and solo timbres. The group of the principal and its subdivisions remained the basis of the Italian organ until the end of the 19th century.

In Germany and France the group of stops inherited from the Medieval instrument, the *mixturen* (mixtures) and *plein jeux* (literally, 'full ranks'), groups which were not subdivided as in the Italian organ, and from which only the lower register was separate, were more compact than in Italy. The size of the reeds was increased in the instruments with larger manuals, and here again there were pedals which allowed the organist to demonstrate his skill. Unfortunately no examples of French or German Medieval organs have survived, and there are few references in literature from which such instruments could be reconstructed.

From a description of the famous organ in Winchester Cathedral (*c.* 980), we learn that the instrument possessed twenty-six bellows and two manuals, each of twenty keys. These keys were not like the modern levers; they were rather connecting rods which projected from the wind-chest, causing ten or more pipes to sound. This continued until the organist pressed on the connecting rods again. The sound could not be varied because the pipes were not separated into stops. The lack of keys controlled by levers did not

20 Upright harpsichord by Albert de Lin. Mid 18th century. Gemeentemuseum, The Hague. Also known as a clavicytherium. This instrument is notable for its decoration of inlaid and gilded wood in the Rococo style of the Louis XV period. The upright case satisfied both practical and decorative requirements. De Lin was active from 1750 to 1770 at Tournai.

21, 22 Spinet by Benedetto Floriani. 1562. Castello Sforzesco, Milan. The irregular polygonal shape of the case is typically Italian. The decorative imagination of the maker has concentrated on the keyboard, richly inlaid with rare woods and ivory, and on the façade bearing a plate with the maker's name and date. Its decorative skill and taste are typical of the Venetian 16th century.

23 Spinet. 18th century. Castello Sforzesco, Milan. This small instrument, Italian in construction, is notable for the clear lines of the case and the traditional landscape decoration.

20 Upright harpsichord by Albert de Lin. Mid 18th century. Gemeentemuseum, The Hague.

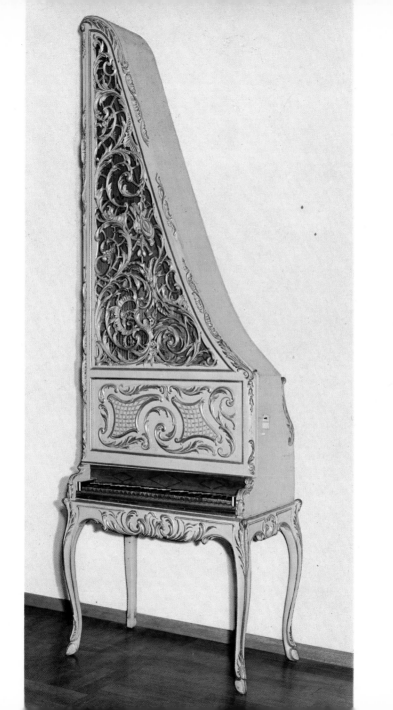

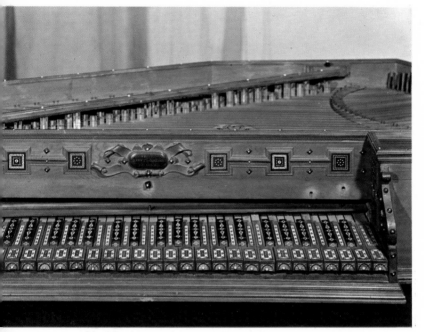

21, 22 Spinet by Benedetto Floriani. 1562. Castello
Sforzesco, Milan.

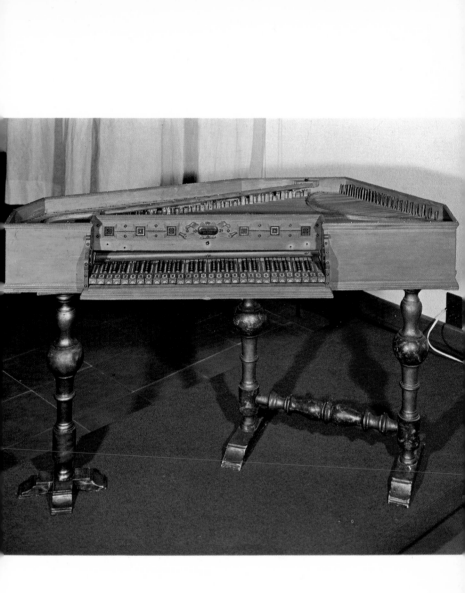

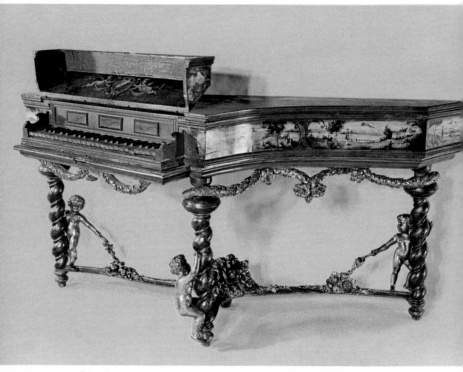

23 Spinet. 18th century. Castello Sforzesco, Milan.

permit, or at least made difficult, any articulation of rhythm in a musical phrase. The operation of the bellows by several persons naturally gave an uneven effect. Consequently these instruments must have produced such a mixture of sounds, and of such intensity that, in the words of a contemporary, 'it sounded like the rumble of distant thunder'. It is difficult for us to imagine the impression that such sonorities must have made.

In the 13th century, important modifications were introduced to control the emission of the sound. Correctly levered keys were eventually constructed, similar to those in use today, which opened and closed the valves automatically. In the 14th century, manuals very similar to our own were being constructed, with keys of two colours.

With this easier mechanism, musical phrases nearer to those of which the human voice is capable could be produced on the organ, and special organ music now began to be written. The popularity of the instrument, and its importance in the liturgy, soon led to the founding of a school for organists and builders, the latter frequently being exponents as well.

Experience and tradition, passed down from master to pupil, flowered in the 15th century, by which time a definite organ-school had come into being, concerned partly with the purely instrumental side

and partly with building techniques. The results are historically ascertainable.

It is enough to mention the *Buxheimer Orgelbuch,* one of the earliest important collections of music for the organ, compiled about 1470 and containing over 250 definitely instrumental pieces, based on both sacred and profane themes and melodies.

As far as the organ itself is concerned, by the end of the 14th century some essential modifications (such as the subdivision of the individual ranks of pipes into stops which could be played both independently and simultaneously) had been made. Solo stops, with timbres different from those of the older group of the diapason and with all the harmonics, had also been introduced. These stops, by contrast with the limpid and metallic tones of the diapason, had a sweeter timbre, more singing and darker; hence they were named after the flute.

Among the builders of the many surviving Italian organs, the name of Lorenzo di Giacomo da Prato is particularly distinguished. His monumental organ, which was finished in 1476, is in S. Petronio, Bologna. Although this imposing instrument has suffered from various restorations over the centuries, it retains its original tone more or less intact. The façade of the beautiful 15th-century case is still extant, and the instrument is not placed against a wall, but between the

right-hand pillars of the central nave. The pipes are divided into five symmetrical sections, and beautifully fretted and carved wooden panels follow the design of the pipes, whose metallic reflections echo the gilding of the case. Unfortunately it is impossible to see the whole case, because in the 17th century it was enclosed in a larger Baroque case of wood and stucco, with statues and bas-reliefs.

In northern Italy the Antegnati family were active throughout the 16th century and into the first decade of the 17th century. The most important members were Graziadio, who was born in 1525, and Costanzo (1549–1624). These Brescian organ-builders are remarkable for both the quantity and quality of their output.

In the famous *Arte Organica,* which Costanzo (who was also an organist) had printed in 1602, is a list of 144 instruments built by the family up to that date, together with a discussion on organ playing. The tone of the instruments constructed by the Antegnati belonged to the tradition of builders in the second half of the 15th century, that of the open diapason – sometimes with sixteen foot double diapason as well – and of the diapason ranks on one hand, and of the flutes on the other, at the octave, twelfth and sometimes also at the fifteenth. The vox humana often appeared as a tremulant flue-stop. The much-reduced pedal

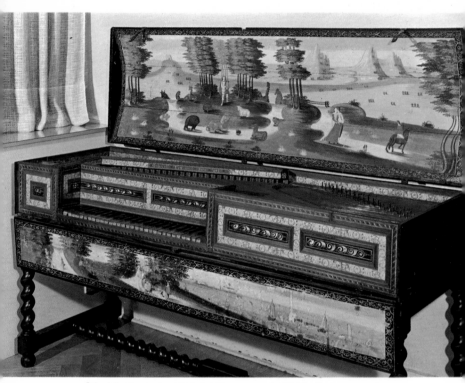

24 Virginals by Gabriel Townsend. 1641. Conservatoire
Royal de Musique, Brussels.

25 French spinet. 18th century. Conservatoire National de Musique, Paris.

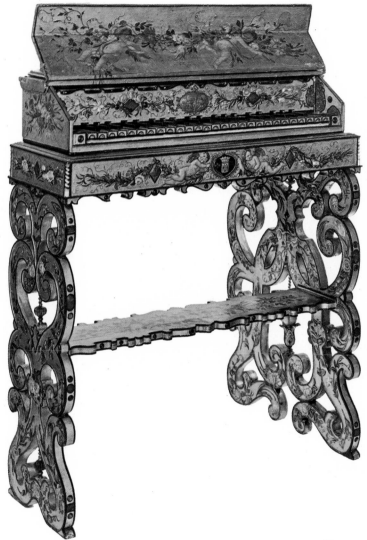

24 Virginals by Gabriel Townsend. 1641. Conservatoire Royal de Musique, Brussels. The earliest surviving example of English virginals. The skilfully painted lid shows Orpheus taming the wild animals. The decoration recalls the work of the Flemish instrument-makers who were popular in England from the late 16th century.

25 French spinet. 18th century. Conservatoire National de Musique, Paris. The whole instrument, from the base up, is painted with floral motifs, cherubs and festoons, and is a fine example of French Rococo taste. The instrument bears the arms of the Orléans family.

26 Spinet by Francesco Battaglia. 1735. Castello Sforzesco, Milan. This instrument shows how Rococo taste revolutionised the traditional, essentially geometrical, shapes and designs of the Italian spinet.

26 Spinet by Francesco Battaglia. 1735. Castello Sforzesco, Milan.

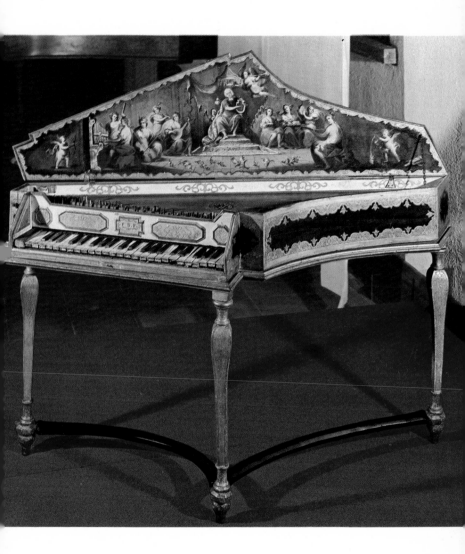

board generally did not possess its own stops. The great technical skill displayed in the construction of the mechanical parts and in the pipes, as well as the tone achieved, have justly made these organs famous. Unfortunately, because of various kinds of damage, often including ill-advised rebuilding, few of these instruments have survived intact. In recent years some have been scientifically restored, and organs by the Antegnati family can now be heard in the churches of S. Carlo and S. Giuseppe at Brescia.

By the 16th century the decoration of the cases and façades of Italian organs displayed Renaissance characteristics. Structural elements, such as pilasters, fluted columns decorated with bunches of grapes, architraves and entablatures in the severe style of early Renaissance architecture, divided the front into sections, enriching it with festoons and cherubs on a background of blue and gold. But the exterior of the Italian organ lacked the three-dimensional quality which characterised the construction of northern, and particularly German organs.

The façade of an Italian Renaissance organ is an architectural tapestry – the wood carving of one master-craftsman enclosing the silvery pipes of another; one visual, one aural. This expressive value was characteristic of the Italian organ up to the end of the 19th century. The 17th- and 18th-century decora-

tive motifs surrounding the pipes accentuated the feeling of depth but did not substantially modify the tradition of simplicity; the Neo-Classicism of the 19th century simplified the lines of the case, a single arch being placed over the geometrical pyramid of the pipes.

The traditional Italian organ lacked certain technical resources. The pedal board, for example, which in Germany was as important as a manual (both in the playing and in the number of its stops), had a limited role, even though it is regularly referred to in some of the oldest manuscripts. Descriptions of typical 16th-century instruments reveal how little the Italian organ changed in the next three centuries. The rare exceptions – such as the organ constructed by Azzolino della Ciaja for the Church of the Knights of St Stefano at Pisa in 1737, with four manuals – had no successors. Some monumental organs in Sicily, from the second half of the 18th century, had a larger casing and more than one manual, it is true; but the manuals were separated from one another, and could only be played by several persons.

In the 19th century a Lombard family of organ-builders, the Serassi, became prominent. The most important, Giuseppe Serassi, was working in the 1820s. He continued to use the traditional mechanism, but added a new crystalline tone to the diapason and other new timbres to the solo stops.

The German organ was influenced in the 14th century by Flemish builders, but it soon acquired individual characteristics, notably greater sonority through the attention given to individual stops. The best known builders were Hendrick Niehoff and the Scherers, who were active during the 16th century in northern and central Germany, and, in the 17th century, Arp Schnitger. These men attempted to modify the sometimes excessive individuality of each separate stop, blend the harmonies more happily, and offer the organist a much greater choice of registration. The Lutheran liturgy required the services of an organ, and composers wrote a great many chorales, demanding from the organ stops a tone suitable for sustaining the tune. Thanks to Schnitger, German organs became the best in Europe at a time rightly regarded as the hey-day of organ construction. In the 18th century the Silbermann family, who were influenced by French techniques, produced important work, mainly in central Germany. Gottfried Silbermann was the best known, building a famous organ in Freiburg Cathedral with more than forty stops. In the last decade of his life he heard of Christofori's invention of hammers, and began constructing pianofortes.

The complex mechanical and speaking apparatus and the presence of several manuals involved several

different cases for the pipes and was responsible for a special 'organ architecture'.

By the 16th century, the German organ had a special feature of its own, the Rückpositiv, or secondary organ, of smaller dimensions. It was called *Rück* (back) because it was originally behind the organist, in the centre of the balustrade of the organ loft, and connected to one of the two manuals of the organ. Usually placed lower than, and in front of, the main organ, it had two functions, musical and architectural. Its tone was sharp and brilliant, and the architectual volume and the disposition of its pipes comprised a decorative complement to the same elements in the bigger organ. From this musical-architectural complex the organ developed logically until the end of the 18th century. Northern imagination, inspired by late Gothic and Baroque, led the organ-builders, carpenters and decorators to develop new and unusual designs. They elaborated the three-dimensional appearance of the pipes, and gave the organ, one of the most solemn of musical instruments, an elaborate or exotic look.

French organ construction – always highly competent – with its two-manual mechanism, also developed differently from the polyphonic Italians or the contrapuntal Germans. Groups of builders, from Lefebvre to Cliquot, Thiérry, and Cavaille, delighted in such stops as *trompet, cromorne, nasard* and *larigot*

27 Flemish clavichord. 17th century. Conservatoire Royal de Musique, Brussels. Note the levers corresponding to the keys. To these are attached the metal tangents or small hammers, which strike the strings, causing them to vibrate.

28 Clavichord by Hieronymus Albrecht Hass. 1744. Conservatoire Royal de Musique, Brussels. This clavichord is larger than its Italian or English contemporaries, and the case lid is simply decorated with a collage of contemporary prints.

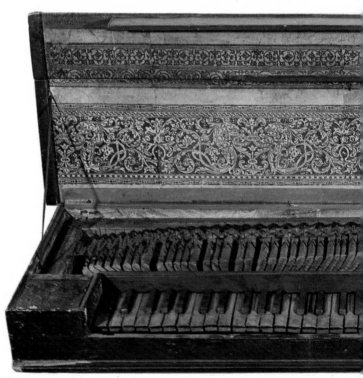

27 Flemish clavichord. 17th century. Conservatoire Royal de Musique, Brussels.

29 Viennese pianoforte. 19th century. Castello Sforzesco, Milan. Here the structure of the harpsichord is repeated, with the outline exaggerated. A massive yet well-proportioned instrument, decorated in the contemporary Neo-Classical style.

30 Upright pianoforte by Friederici di Gera. 1745. Conservatoire Royal de Musique, Brussels. The symmetrical pyramid form was often used for the case, and was much appreciated by musicians.

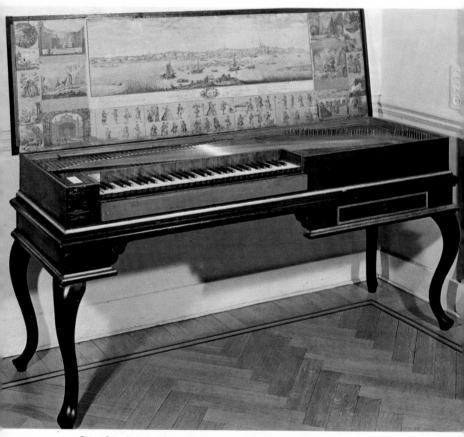

28 Clavichord by Hieronymus Albrecht Hass. 1744.
Conservatoire Royal de Musique, Brussels.

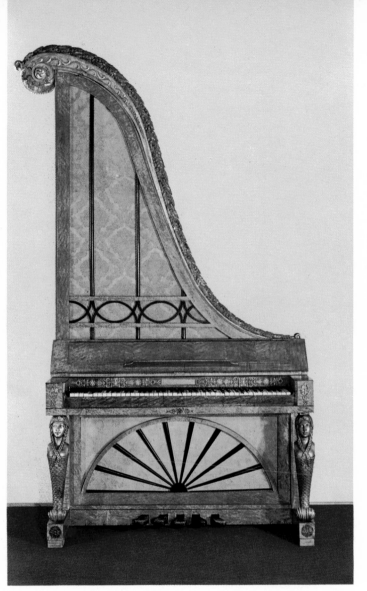

29 Viennese pianoforte. 19th century. Castello Sforzesco,
Milan.

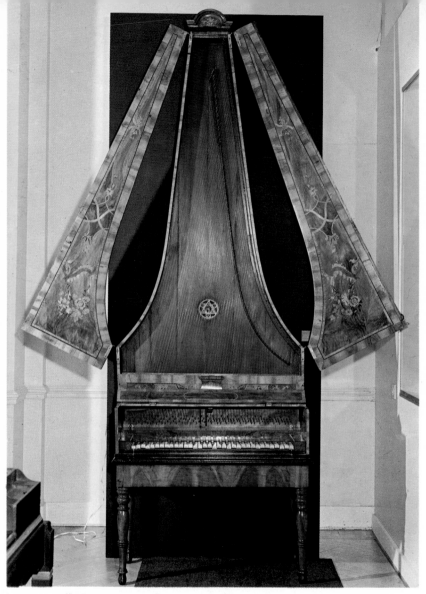

30 Upright pianoforte by Friederici di Gera. 1745.
Conservatoire Royal de Musique, Brussels.

(a kind of flute). The principal acoustic effects on which the many stops of the French organ are based were traditional, but its quality, clarity of tone and clear enunciation distinguish it from all others.

The structure of monumental organs was adapted to their surroundings and the style of the period, as for small movable organs, For keyboard instruments such as the harpsichord and pianoforte, even more successful effects were obtained.

THE HARPSICHORD

The harpsichord probably derives from the psaltery, but no explanation has yet been found of the development from stringed instruments plucked by the fingers to those plucked by a mechanical plectrum operated by a key. However, illustrated manuscripts provide documentary evidence that the harpsichord was in use in the first decades of the 15th century.

The earliest surviving example of a harpsichord, made in Rome by Gerolamo Bolognese in 1521, is now in the Victoria and Albert Museum in London; its form has not changed since then. The shape is virtually that of a grand piano, but narrower and more delicate and fragile. For those unacquainted with the nature and technical structure of the harpsichord, the

simplest analogy is that of the pianoforte, although only the external appearances are similar. Like all instruments, harpsichords require a soundboard, a hollow wooden body capable of receiving and emitting the vibrations of the strings. In this case the soundboard influences the shape and size of the instrument. Bass notes require long, heavy strings, and high-pitched ones short, light strings. The shape of the case was therefore that of a right-angled triangle, with the right angle on the left. The angles were rounded, and the front part prolonged to facilitate the use of the keys. The result was a shape common to both harpsichord and pianoforte.

However, comparison between the two instruments reveals that, whereas the mechanism of the harpsichord attempts to reproduce the effect of a finger plucking a taut string, the pianoforte contains a much more complex and studied mechanism involving the vibration of a string struck by a hammer. If percussion is more artificial than the act of plucking, in the case of the pianoforte it nevertheless transmits a live vibration, the pianist's 'touch', to the string, and so achieves a more personal result than is possible on a harpsichord.

The simplest type of harpsichord possesses only one row of strings, one to each key, and one keyboard of four octaves. Inside the instrument, at the end of each key-lever, is a wooden rod called a jack, placed verti-

cally beside the string. Set in each rod is a moveable tongue with a quill on it (or sometimes a thorn). The depression of the key raises the jack, and the quill plucks the string; when the key is released, the moveable tongue allows the quill to avoid touching the string again. Just as the organ has many sets of pipes, so the harpsichord may have several rows of strings, or several stops; these can be tuned in unison, as in the organ, and are designated as eight feet. Otherwise they can be tuned to a higher octave, so that they are known as four-feet stops. Each stop has, naturally, to have its own row of jacks, all connected to the individual notes of the keyboard.

By the 16th century, instruments with two keyboards or manuals, and therefore with several stops, were already in existence. As in the case of the organ, the use of two manuals permitted various timbres, from the deep eight-foot stop on the first manual to the more delicate ones on the second. In addition, the clearer, more brilliant tones of the four-foot stop could be employed. The two manuals could be coupled, and the maximum sound produced when all the stops were out. Two manuals and three stops, the minimum in the case of a harpsichord of this type, allowed the player at least six tonal variations. Other, later devices permitted a more muffled tone on the same stops, the 'theorbo effect'.

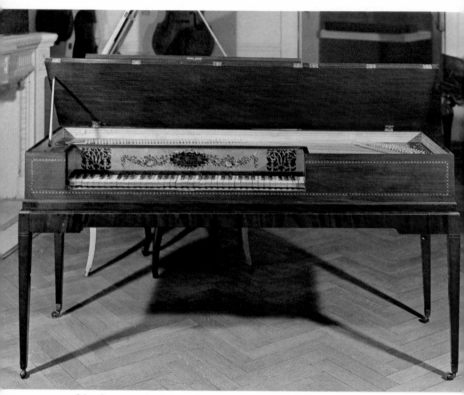

31 Square pianoforte by Muzio Clementi, *c.*1810.
Conservatoire Royal de Musique, Brussels.

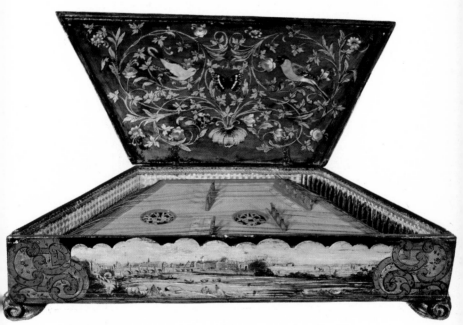

32 Psaltery with case. Late 17th century. Castello Sforzesco, Milan.

31 Square pianoforte by Muzio Clementi, *c*. 1810. Conservatoire Royal de Musique, Brussels. Clementi, well known as a composer and pianist, was also a piano-maker. The severe lines and simple rectangular case are typical of late Empire style, and are reminiscent of the older clavichords.

32 Psaltery. Late 17th century. Castello Sforzesco, Milan. Played by plucking the strings with the fingers or a plectrum. The trapezoidal shape was the most common at this time. Although the notes were weak, their very individual tone was appreciated.

33 French harp. 17th century. Conservatoire Royal de Musique, Brussels. The sound produced by this is similar to that of the psaltery, of which this instrument is a variant. The strings are stretched on both sides of the soundboard, and are plucked with both hands. The instrument is played on a table or on the knees.

34 Hurdy-gurdy. 1768. Musée des Arts Décoratifs, Paris. The strings were stretched over the soundboard and made to vibrate by a wooden wheel which was operated by a handle. When the keys were depressed a mechanism operated to stop the strings. The hurdy-gurdy was played on the lap, or suspended from the neck.

33 French harp. 17th century. Conservatoire Royal de Musique, Brussels.

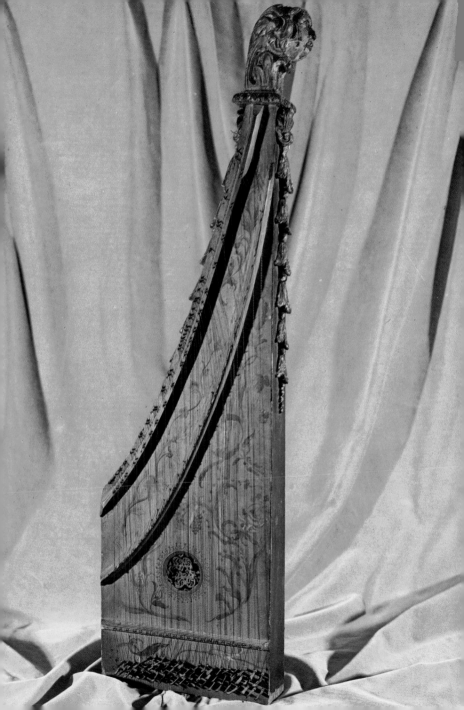

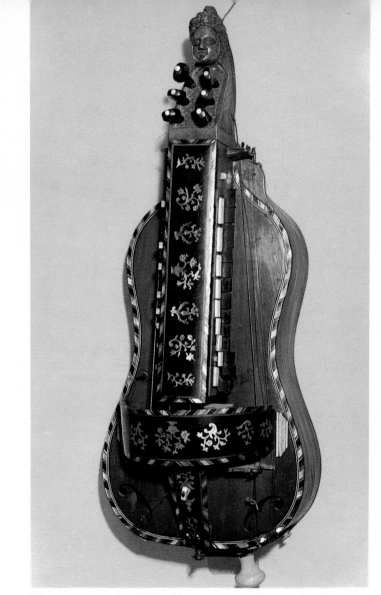

34 Hurdy-gurdy. 1768. Musée des Arts Décoratifs, Paris.

SPINET, VIRGINALS, CLAVICHORD

Other important instruments with keyboards, played
mechanically like the harpsichord, but of smaller
dimensions and less sonority, and with differently
shaped cases, were the virginals and the spinet. They
were smaller, simpler and easier to move than the
heavy harpsichord; basically, they differed from it
only in sonority, being less loud because of the smaller
soundboard. They can in façt be regarded as the
domestic counterpart of the harpsichord, rather as
today we distinguish between the upright and grand
piano.

Very different from the harpsichord, and in a sense
the direct ancestor of the pianoforte, is the clavichord.
Of all the keyboard instruments, the clavichord
possesses the simple form of mechanism combined
with the greatest tonal sensitivity. It is rectangular in
shape and has no base of its own. The keyboard is
towards the left-hand end of the long side; on the right
is a wooden block into which the pegs are fixed at
right angles to the keyboard, and from which the
strings are stretched. When a key is depressed, a thin
plate of metal, called a tangent, strikes a string. It is
here that the mechanical difference between clavi-
chord and harpsichord is especially apparent. In the
harpsichord the strings are plucked and vibrate freely,

while in the clavichord the tangent stays in contact with the string; there is thus direct contact between the hand of the player and the strings. This permits special effects such as the vibrato.

THE PIANOFORTE

Because of its feebler, if more expressive, tone the clavichord remained a small instrument with a single keyboard. At the beginning of the 18th century an Italian, Bartolommeo Cristofori, added certain important modifications in string percussion to existing keyboards thus creating a new instrument which soon supplanted its predecessors. The important feature of Cristofori's invention was that the hammer was not attached at the end of the key but was so placed that immediately it struck the string it withdrew and did not stay in contact. All sorts of tonal and expressive variations were thus made possible. This, and other subsequent improvements to the instrument, makes the pianoforte the most revolutionary development of all. If the clavichord can reasonably be considered the ancestor of the pianoforte, it must also be admitted that no improvement or invention could have enabled it to go beyond certain limits; it was bound to remain an instrument of delicate timbre, a full stop in the

history of music. Music from the end of the 18th century to the present day has exploited to the full the more powerful and varied tones of the pianoforte.

Modern study and research give pre-eminence to Italian harpsichord builders. Most of the instruments that have survived, or whose construction is referred to in documents, are of Italian origin from the early 16th century. Certain documents also refer to Italian builders in the last decades of the 15th century.

The Italians used cypress wood for the case, since it has a compact fibre and is rarely attacked by wood-worm. Their preference was for a small instrument, usually with only one manual and two series of strings, tuned in unison. Harpsichords with two manuals did not appear until the 17th century, and then only rarely. Spinets were also popular as convenient domestic instruments. They were usually polygonal in shape, having the keyboard almost in the centre, and one row of strings. The dimensions were small, and sometimes the spinet had only one octave. It appears, too, that the unusually shaped upright harpsichord or clavicytherium originated in Italy.

As in the case of the organ, and for the same reasons, the Italian harpsichord did not alter much during the 17th and 18th centuries, retaining the dulcet tones of its 16th-century original.

The names of certain Italian makers are known from

the 16th century onward. In 1461, a certain Sesto Tantini wrote from Modena to Duke Borso d'Este asking to be paid for a harpsichord which he had sent to the duke. Another Modenese, Allessandro Pasi, was active at the end of the century. The earliest surviving signed and dated Italian instrument, the authenticity of which is undoubted, is by Girolamo da Bologna, made in Rome in 1521. It is now in the Victoria and Albert Museum, London, in a hide-covered case with rich gilded motifs and lined with green vellum. Nothing is known of its maker apart from his name.

In his autobiography, Benvenuto Cellini says that his father Giovanni 'constructed organs from marvellous woods, harpsichords which were the finest and most beautiful to be seen at the time, and viols, lutes, and the most beautiful and excellent harps'.

It appears that a Venetian school was founded in the second half of the 16th century by Giovanni Antonio Baffo. A dozen or so of his instruments have survived, including a harpsichord with two manuals, and are now in various museums of Europe and North America. Alessandro Bertolotti, Giovanni Celestini (working until 1610) and Alessandro and Vito Trasuntino were also members of the Venetian school. Trasuntino is known as the author of the famous 'archicembalo', now in the Museo Civico of Bologna. This instrument

35 Hurdy-gurdy by César Pons. 1770. Conservatoire Royal de Musique, Brussels.

35 Hurdy-gurdy by César Pons. 1770. Conservatoire Royal de Musique, Brussels. The maker, César Pons, worked in Grenoble in the second half of the 18th century. He sometimes added small pipes to his hurdy-gurdy, and the wind was produced by a handle. The border was often decorated. There seem to be no accounts of the strange sound medly this instrument must have emitted.

36 Treble viol by Heinrich Ebert. Second half of the 17th century. Conservatoire Royal de Musique, Brussels. Small, and therefore high-pitched, this instrument was played on the knees.

37 Viola da gamba by Joseph Stoss. 1718. Wagner Museum, Lucerne. Note the deep, C-shaped bouts, the gently sloping shoulders, the rosette and scrolling sound-holes on the soundboard. This type of sound-hole is called a flame-hole, and is thought to be related to Islamic motifs — a reminder of the Arab ancestry of European bowed instruments.

38 Instrument dating from the 18th century. Castello Sforzesco, Milan. Makers sometimes indulged in eccentric experiments, as with this violin-type instrument shaped like a guitar. Its unknown maker has inlaid the back amusingly.

36 Treble viol by Heinrich Ebert. Second half of the 17th century. Conservatoire Royal de Musique, Brussels.

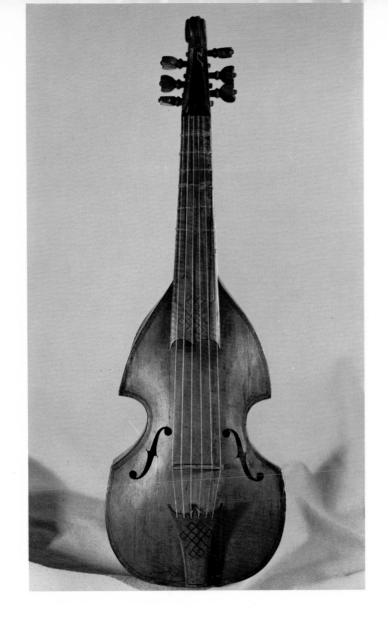

85

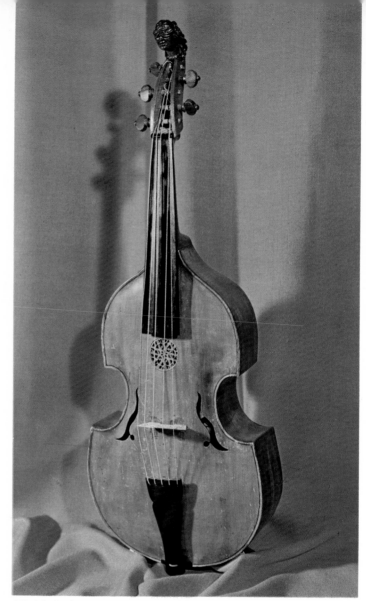

37 Viola da gamba by Joseph Stoss, 1718. Wagner
Museum, Lucerne.

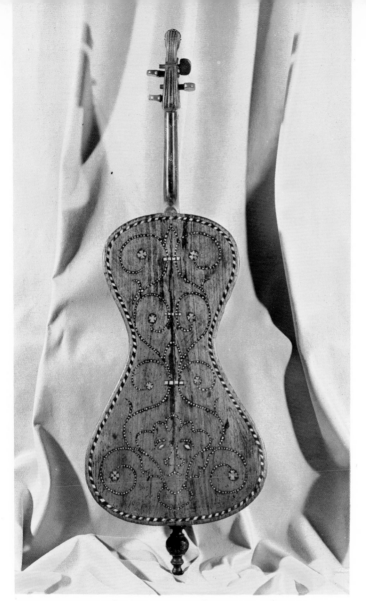

38 Instrument dating from the 18th century. Castello
Sforzesco, Milan.

was made in 1606 as a scientific experiment, the object being to demonstrate theories about ancient music, which obsessed the theorists of the day. It had a keyboard of four octaves, each tone being divided into four (not into semitones, as is usual), so that the interval between each tone, normally separated by a semitone (the black key), was divided into four (four keys, one above the other); consequently the intervening semitone (two adjacent white keys) was divided into two quarter tones (two keys one above the other). Thus the scale had twenty-four keys, instead of twelve as in our present day system.

In northern Italy, Francesco Portalupi of Verona and Francesco Patavino were still active in the 16th century. In Milan, the Rossi family, Annibale and Ferrante, were constructing well-made spinets of which there are examples in the Museo Civico, Turin, and the Victoria and Albert Museum, London; 17th-century makers of some note were Nicolao de Cuoco, who had a workshop in Florence, and Fabi of Bologna. Two very beautiful harpsichords by Fabi, the cases and the keys richly inlaid, are now in the Conservatoire in Paris.

In 1655, Bartolommeo Cristofori, already mentioned in connection with the pianoforte, was born in Padua. A skilled maker of harpsichords, he was summoned to the court of Ferdinando de'Medici in Florence to take

charge of the prince's famous collection of about eighty instruments, of which approximately half had keyboards. He remained there until his death in 1731, and during this long period he constructed new harpsichords for the prince and the noble families of Florence, and introduced a novel mechanical form for controlling the volume of sound. In 1711 a letter from Scipione Maffei, published in the *Giornale dei Letterati d'Italis,* mention four *'gravicembali col piano e forte'* (with soft and loud), the work of Cristofori. In the 19th century, Alessandro Riva of Bergamo continued the great Italian tradition.

Another great European school was that of the Flemish, originally inspired by the Italians. This school in turn gave rise to the schools of France, England and Germany. There were expert Flemish builders, organised in a powerful guild, even before the advent of Hans Ruckers and his sons, who are rightly considered the greatest harpsichord makers. Ruckers was born in the middle of the 16th century, probably at Malines. He was admitted to the Antwerp guild of harpsichord builders in 1579, and was succeeded by his sons, Jan and Andries, and various nephews; so that the Ruckers family was active into the middle of the 17th century.

Many of the instruments signed by the family have survived. Broadly speaking, they are of two types:

the harpsichord with one manual, of four octaves and two stops, one of eight and the other of four feet; and the harpsichord with two manuals, the lower of which is slightly more extended than the upper, of four octaves. In the second type there were still two stops, but two series of jacks to each manual, placed at different points of the strings, allowed a certain variation in tone.

The Ruckers also constructed spinets. The shape was rectangular (although one of them, dated 1591, is hexagonal), in the Italian form of spinet. Notable among many special features, which lack of space makes it impossible to describe here, was the position of the manual on the long side of the case. When placed on the left, the jacks plucked the strings near the bridge over which they were stretched, producing great brilliance of sound. When placed on the right, they plucked the strings in the middle, rendering the sound less penetrating and more muffled.

In France there were many theories about the construction of keyboard instruments from the 15th century onwards, but no French examples from before the mid 17th century have survived. Even here, harpsichords built by the Denis family are extremely rare. More interesting is Jean Marius, who was working in Paris in the early 18th century. A talented construc-tor, he invented the *clavecin brisé,* a small portable

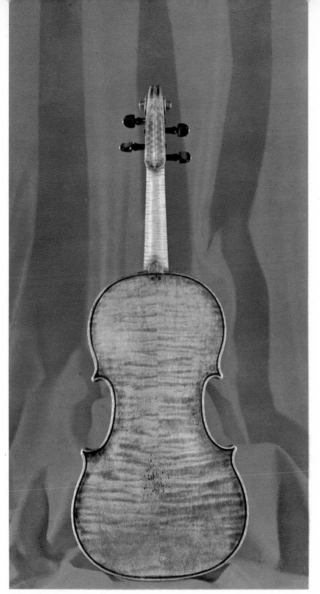

39 Violin by Antonio Stradivarius. 1671. Castello Sforzesco, Milan.

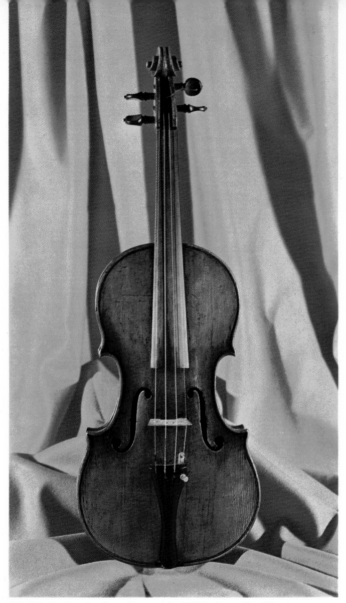

40 Violin by Andrea Guarneri. 1694. Castello Sforzesco, Milan.

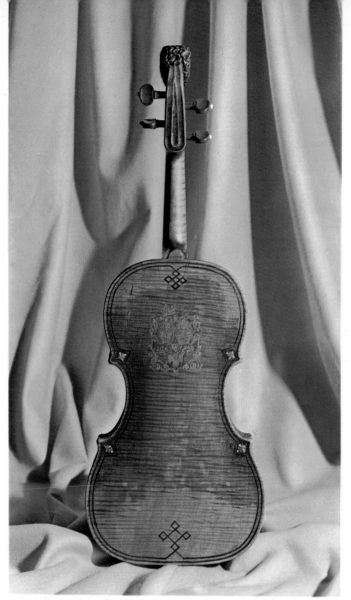

41 Violin by Kaspar Duiftoprugcar (Tieffenbrucker).
Mid 16th century. Castello Sforzesco, Milan.

39 Violin by Antonio Stradivarius. 1671. Castello Sforzesco, Milan. The excellent proportions and clear outlines of this violin betray the hand of the great Cremonese maker; they are emphasised by this back view.

40 Violin by Andrea Guarneri. 1694. Castello Sforzesco, Milan. Guarneri was, like Stradivarius, a pupil of Nicola Amati, although about twenty years older than his fellow-pupil. Andrea Guarneri was the founder of the famous family of violin-makers. In the elegant proportions of this fine violin, made in the last years of his working life, the influence of his greater contemporary is clearly visible.

41 Violin by Kaspar Duiffoprugcar (Tieffenbrucker). Mid 16th century. Castello Sforzesco, Milan. This maker, who was probably not related to Magnus Tieffenbrucker, was working in Lyons until 1571. Today he is considered one of the most important contributors to the improvement of bowed instruments.

42 Viola by Jacob Stainer. 17th century. Castello Sforzesco, Milan. Regarded as the Stradivarius of Germany, Stainer made instruments which reveal the influence of Amati, though there is no evidence that he was his pupil.

42 Viola by Jacob Stainer. 17th century. Castello Sforzesco, Milan.

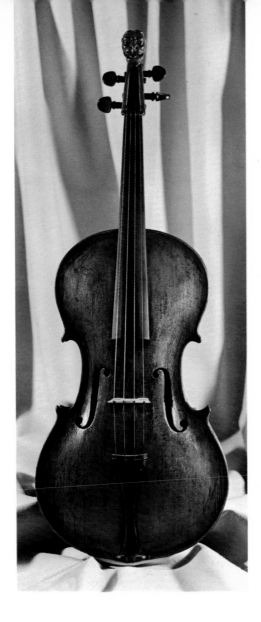

harpsichord in three separate sections which were joined by hinges and could therefore be folded. He also elaborated the technique of percussion by small hammers, at about the same period as the Italian Cristofori. French harpsichords are almost always constructed with two manuals, after the Flemish manner, and are notable for the same full-bodied tone.

During the period of the great French harpsichordists, such as Couperin and Rameau, a remarkable builder, Nicolas Blanchet, appeared, followed by his sons, and later by Pascal Taskin. He spent the last years of his life, at the end of the 18th century, in perfecting the mechanics of the pianoforte. These great craftsmen spent much of their time restoring and adapting to contemporary taste a number of harpsichords made by the Ruckers in the previous century. To Blanchet and Taskin must also go the credit of appreciating the quality of the instruments constructed a century earlier, and of having kept them in good condition, thereby enabling much of the Ruckers' work to survive today.

The favour with which these instruments were received in England in the 16th century may be judged from the inventories and account books of the English court during the reigns of Henry VII and Henry VIII. Particularly interesting is an inventory dated 1547,

the last year of Henry VIII's reign, which lists the musical instruments in the various royal palaces: lutes, flutes, organs and virginals of every shape and size. Dates are not attributed, but it appears that a large proportion of the instruments were of Italian origin.

In Germany, many accounts by theorists refer to the popularity of the various forms of harpsichord. Exact descriptions, in publications illustrated with engravings, furnish useful information. It is sufficient to mention Sebastian Virdung's *Musica Getutscht* (i.e., 'Music in the German Language'), published in 1511, in which the monochord, the clavichord, the virginals, the harpsichord, the clavicytherium, the organ and many other instruments are actually described.

No instruments made before the 18th century have survived. The clavichord was popular, and many examples have survived, sometimes with pedals, which resembled the organ; in fact it was easier for players to practise on this instrument than on the organ. Famous constructors included Hieronymus Albrecht Hass and his son Johann Adolph, both active in the 18th century, of whose work various high-quality examples have survived. It was they who first gave the harpsichord a sixteen-foot stop, a row of strings tuned to an octave below the normal, which in certain instruments is enclosed in its individual case.

The organ-builder Gottfried Silbermann also constructed harpsichords. In his later years he became acquainted with Cristofori's invention, and succeeded in perfecting the mechanism of what was to become the pianoforte, with excellent results. Almost all the builders of the 18th century were concerned with the new instrument, as well as with the two traditional types. Johann Andreas Stein must be mentioned for the quality of his instruments, which were used by Mozart.

The pianoforte did not immediately supplant harpsichords and clavichords. At first it was not regarded as a serious rival to the harpsichord, and the quality of its tone differed chiefly in the control over the vibration of the strings which the executant now possessed. It is worth noting that even in 1820 Giuseppe Verdi used to practise on the simple polygonal spinet which is now in the Museo Teatrale of La Scala in Milan.

Towards the end of the 18th century, however, the mechanism of the pianoforte was progressively improved, especially by Sébastien Erard. Upright pianofortes were patented and called piano cabinets with a system of all-metal frames which allowed more stable tuning. The fine tone stimulated the curiosity of composers.

As to the decoration of these keyboard instruments,

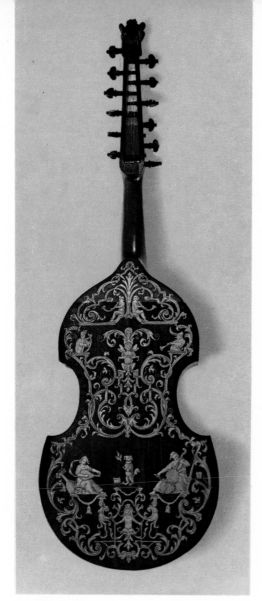

43 Viola d'amore by Kaspar Stadler. 1714. Germanisches
Nationalmuseum, Nuremberg.

44 Lower portion of a viol by Joachim Tielke. 1701.
Conservatoire Royal de Musique, Brussels.

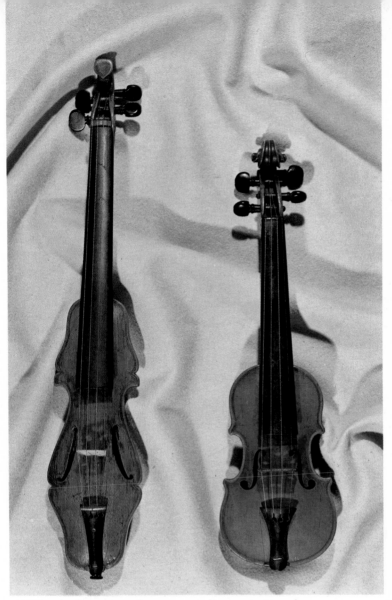

45 Kits. 18th century. Conservatoire Royal de Musique,
Brussels.

43 Viola d'amore by Kaspar Stadler. 1714. Germanisches Nationalmuseum, Nuremberg. This maker, who worked in Munich during the first half of the 18th century, appears to have made only a limited number of instruments. The archaic form is embellished with coloured wood inlays which cover the entire body.

44 Lower portion of a viol by Joachim Tielke. 1701. Conservatoire Royal de Musique, Brussels. The thickness of the ivory-banded ribs, and the shape of the tail-piece, in the form of two intertwined serpents, are representative of the fine workmanship of this German maker. Famous in his own day, his instruments are now valuable collectors' pieces.

45 Kits. 18th century. Conservatoire Royal de Musique, Brussels. These miniature violins were very popular in the 18th century, and much in demand among dancing teachers. They were often called 'pochettes' from the French *poche* (pocket), signifying that they were 'pocket violins'.

46 Cittern. 17th century. Conservatoire Royal de Musique, Brussels. This instrument was popular from the 16th to the 18th centuries. Known also as a cithern or sistrum, it had a variety of shapes. Like the guitar, it was played by plucking the strings with the finger or with a plectrum.

46 Cittern. 17th century. Conservatoire Royal de Musique, Brussels.

Italy preferred sober motifs for the actual case, at least during the 16th century, while the lid was often covered externally with leather and designs inlaid with gold, and its interior with velvet or some other precious material. In the 17th century, the interior of the lid (which was lifted when the instrument was being played) began to be painted in tempera with mythological scenes, preferably relating to music: stories of Orpheus, Amphion and Parnassus. The Flemish preferred paintings of everyday life, with landscapes and musical parties in the courtyards or gardens of some noble residence.

Particular attention was paid to the decoration of the panel above the keyboard; the name of the maker and the date were frequently inscribed there, either in inlay or paint. Sometimes it was decorated with a geometrical design, elegantly carved, and continued at the sides of the keyboard. This form of decoration was liable to go from one extreme to another, from the simplicity of the early Italian instruments, with the lower keys of boxwood and the upper of ivory, to certain Flemish examples decorated with fantastic inlays.

An effective Flemish technique, found especially on instruments made by the Ruckers, was to glue strips of cardboard, printed in black and white with recurring floral designs, on to the sides, internal

borders and all visible parts; these strips were made resistant by varnish, and the main design was heightened with water-colours.

Instruments were usually embellished by furniture decorators; and one would therefore not expect to find them decorated by artists of any note. It is known, however, that the famous singer Farinelli owned a harpsichord painted by Gaspard Poussin. At the Hermitage Gallery in Leningrad there is a picture attributed to Bronzino which depicts Apollo and Marsyas; the shape, an irregular polygon (changed later into a rectangle and retouched), is almost certainly that of a harpsichord lid.

Most of these instruments, especially the older ones, have no base and feet. They were usually placed on a piece of furniture, and it was only at the end of the 18th century, when the taste for French furniture was at its height, that this final touch was added. An outstanding exception is the base of a 17th-century Italian harpsichord, now in the Metropolitan Museum, New York, which is carved in gilded wood.

BOWED INSTRUMENTS

From the 18th century the musical world was dominated by bowed instruments. It would be no exaggera-

tion to describe it as an empire which extended chronologically (the foundations being laid by the Arabs) throughout the Middle Ages, and which still competes in importance, even for contemporary scores, with electronic instruments. They operate according to a principle of sound emission that is simple enough: a stretched string which vibrates owing to friction with another object, and a sound-board which is joined to the string and amplifies the volume, giving quality to the tone. This is still the primitive form of various Oriental instruments, and it is probably from the East, through the Arabs, that the ancestors of modern bowed instruments spread throughout Europe in the Middle Ages.

The Italian term *ad arco,* which covers this great family of instruments is precise in its definition; the bow produces the sound against the strings, which are stretched on a soundboard transmitting and amplifying the vibrations.

Up to the middle of the 18th century, the bow was somewhat different from its modern counterpart. Horsehair was stretched between the two ends of a wooden bow similar to the weapon from which it took its name, as can frequently be seen in pictures or illustrated manuscripts. The sound produced was smaller in volume but more iridescent than that produced today. In the course of the 18th century, the

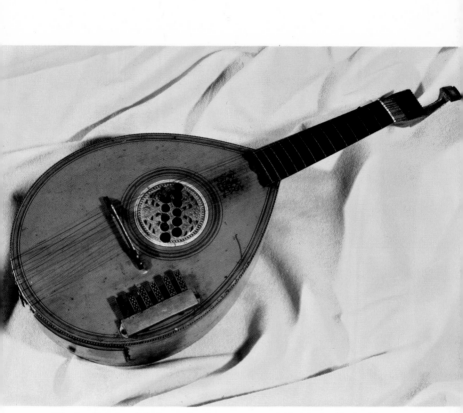

47 English keyed cittern by Longman and Broderip. End of the 18th century. Conservatoire Royal de Musique, Brussels.

47 English keyed cittern by Longman and Broderip. End of the 18th century. Conservatoire Royal de Musique, Brussels. Popular chiefly in England, this instrument possessed a technical device inside the case by which the strings were struck by small hammers, worked by six keys corresponding to the perforations in the sound-hole.

48 Lute by Giovanni Hieber. Second half of the 16th century Conservatoire Royal de Musique, Brussels. The proportions of this lute were carefully calculated; its severe lines, from which all extraneous decoration is excluded except the perforation of the sound-hole, make it a rare and balanced instrument. Hieber was of German origin, but worked in Venice and Padua until the third decade of the 17th century.

49 Penorcon. 17th century. Conservatoire Royal de Musique, Brussels. This instrument belongs to the lute family, but has nine double strings. The scroll at the end near the pegs is unusual, but the design is aesthetically satisfying.

50 Soprano lute. 18th century. Castello Sforzesco, Milan. Notable for the valuable inlays of ebony, ivory and mother of pearl on the neck and back. This instrument has twelve strings and, because of its small size (about 23 ins long), was known as a soprano lute.

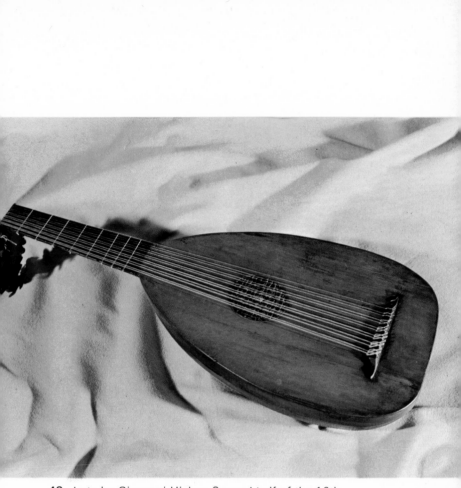

48 Lute by Giovanni Hieber. Second half of the 16th century. Conservatoire Royal de Musique, Brussels.

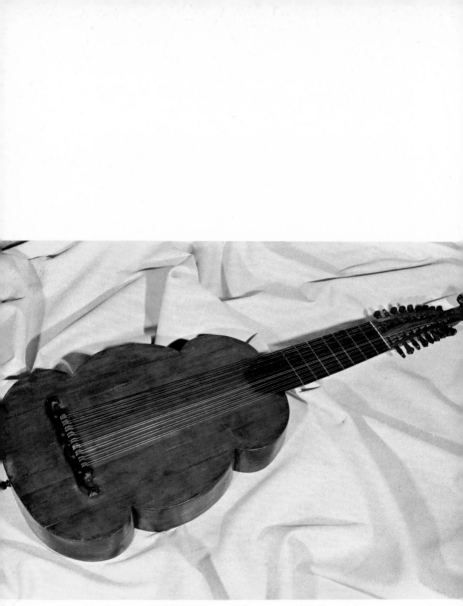

49 Penorcon. 17th century. Conservatoire Royal de Musique, Brussels.

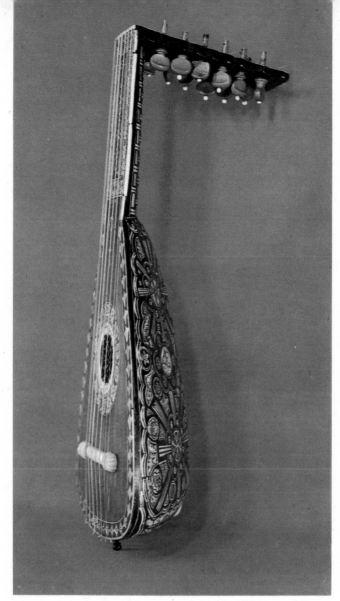

50 Soprano lute. 18th century. Castello Sforzesco, Milan.

Italian Guiseppe Tartini and the Frenchman François Tourte developed the bow until it acquired its modern form and length. Its shape has been a subject of discussion in connection with how ancient music was produced, and how the primitive bow was adapted to it. Some instrumentalists who specialise in this music employ the older type of bow.

THE VIOLIN

It is the construction of these instruments that requires the most explanation, and particularly their shape. Few variations are possible, for an instrument whose form corresponds to a definite function quickly becomes standardised. Nevertheless, first class craftsmen confronted by such difficulties, were inspired to solve them skilfully, not only by their inlays and carvings, but in the more detailed work which gives these instruments their abstract beauty. Even the strict rules of the lute- or violin-makers allowed variations. The complicated elements of a violin, for example, are combined harmoniously within one body, which has an upper portion called the soundboard (table or belly) and a lower portion (the back) joined at the edges by ribs. On the sides are two indentations or bouts, and in the middle of the soundboard

two f's or sound-holes, long slits which are similar in shape to the profile of the instrument, and which are openings for the emission of sound. The bridge between the two f's, a thin strip of maple wood over which the strings are stretched, communicates the vibrations to the body of the instrument.

Two other elements enclosed within the body are acoustically important: the bass bar, a thin strip of spruce beneath the soundboard case and under the left foot of the bridge; and the sound post, a slender spruce cylinder embedded between the soundboard and the back, under the right foot of the bridge. These parts, being in communication with the bridge, over which the strings are stretched, transmit the vibrations to the front and back of the instrument. On the upper part of the body is the neck of the instrument, attached to the upper ribs and terminating in the scroll. The sides of the neck hold the pegs used for tuning the strings, while the front carries the fingerboard. The four strings stretch from the tail piece (an ebony strip held by strong catgut to a knob on the lower rib of the instrument), over the arch-shaped bridge, to the scroll, where they are held in place by the pegs. This, then, is the basic nomenclature of the violin, as of all modern bowed instruments certain details were added in time, but the principal parts here described are found in the oldest instruments.

THE VIOLS

The viol in its many forms is generally acknowledged to be the ancestor of present-day bowed instruments. Illuminated manuscripts prove that a bowed instrument was being used in Europe at the beginning of this millennium, and it is clear from 14th-century manuscripts that viols similar to those used in the Renaissance (a few examples of which have survived) were already being played. A variety of shapes was adopted for bowed instruments, since artisans and musicians were ever inventing new techniques and giving free play to their fancy. From this fortunate confusion a musical civilisation with new instruments emerged at the beginning of the 16th century; while polyphonic music was about to reach even greater heights.

New rules were made, most of them concerned with the human voice, which was then the most important 'instrument'; and the construction of all instruments was improved. Similarities of shape, tone, and execution necessitated the division of these instruments into groups. At the end of the 15th century, the first distinctions were made between members of the viol family: the viola da braccio (arm), played against the left shoulder, with the bow in the right hand; and the viola da gamba (leg), played by holding it on the lap

51 Chittarone by Magnus Duiffoprugcar (Tieffenbrucker). Venice. 1593. Castello Sforzesco, Milan.

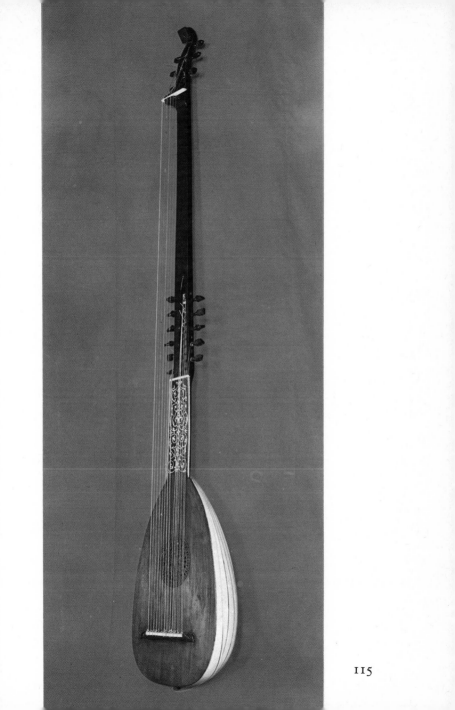

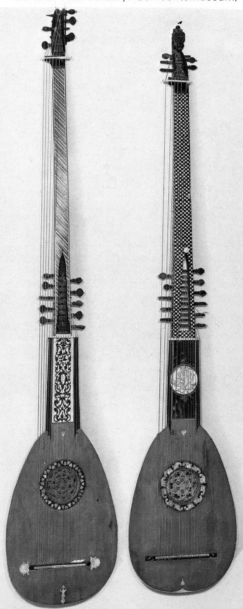

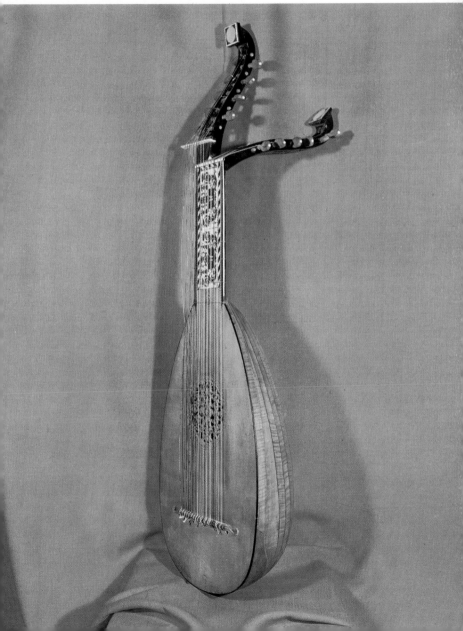

51 Chitarrone by Magnus Duiffoprugcar (Tieffenbrucker). Venice, 1593. Castello Sforzesco, Milan. According to tradition, this fine instrument once belonged to Claudio Monteverdi. The back of the case is of ivory, in fifteen parts separated by ebony strips. The elegant shape of the whole, together with the highly skilled inlay work, make this one of the most remarkable examples of 16th-century work.

52 Chitarrones. 16th century. Gemeentemuseum, The Hague. The warm sonority of this instrument, which was derived from the lute, earned it a place in musical ensembles even after the 18th century. The sound-holes, necks and fingerboards of these two examples are finely decorated in ivory and mother of pearl.

53 Theorbo lute by Magnus Duiffoprugcar (Tieffenbrucker). 1610. Wagner Museum, Lucerne. Another example from the Venetian workshop of this famous Bavarian maker. This instrument is halfway between the common lute and the theorbo.

54 Colascione. Beginning of the 17th century. Gemeente-museum, The Hague. This instrument belonged to the lute family and was popular in southern Italy until the middle of the 17th century. It was played with a plectrum, and usually had only three strings, as in this elegant example.

54 Colascione. Beginning of the 17th century.
Gemeentemuseum, The Hague.

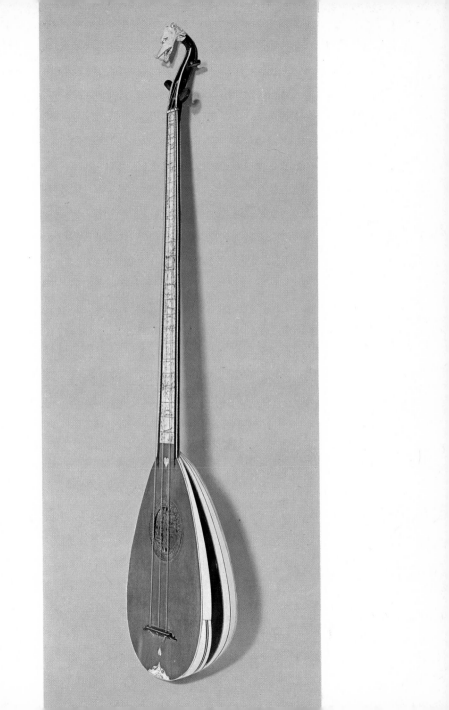

or between the legs. Modern instruments, the violin, cello and double-bass, derive in construction and sound production from the *viola da braccio* group.

The viola da gamba had sloping shoulders, a straight, flat back, and higher ribs. The bridge was flatter than in modern instruments, which faciliated the playing of chords. A whole family was derived from this instrument, including the treble, alto, tenor and bass viols. In the 17th century the violin family, which had derived from the viola da braccio, became more popular. Of the viola da gamba family, the tenor viol survived until the 18th century, when it was replaced by the cello.

The first true violins came from the workshops of Andrea Amati of Cremona (died in 1579) and the Brescian Gaspare da Salo (born in 1540). Although Amati is usually considered the greater, the Lombard makers were very highly regarded.

Each of the two masters had famous pupils. Maggini, born in 1540, came from the school of Gaspare da Salò, while Andrea Amati's sons Antonio and Gerolamo carried on the Cremonese tradition. The famous Bartolomeo Giuseppe Guarneri (known as 'Jesus') was the son of a certain Andrea, who was a pupil of Nicola, the nephew of Amati. The last of these makers, such as Cerutti and Storione, were still working in the 19th century. Apart from Brescia and

Cremona, there was an important independent school in the Tyrol, whose chief representative in the 17th century was Jacob Stainer.

However, the present form of the bowed instrument derives from the legendary Antonio Stradivari, better known under the Latinised form of his name, Stradivarius. His earliest violins appeared in about 1665, while he was still working in the studio of Nicola Amati. Suddenly he became so well known that James II of England ordered five of his bowed instruments.

Stradivarius's excellence lay in his ability to assess the resonance of woods; he constructed so that the minutest change in case vibration, caused by the thickness, the convex form of the table or the back, or the length of the ribs, could be registered. His intuition enabled him to design the various members so that the subtlest string vibration could be appreciated. The woods he usually employed were maple for the back and outer parts, and red spruce for the table. His varnishes for the various coats were also famous, ranging from orange to a reddish-brown. The varnish is important because it protects the wood and encases the individual parts in a kind of vibrating skin. As is well known, Stradivarius violins have been given individual names, often those of their most illustrious owners. They include the 'Viotti', constructed in

1709, and now in the Conservatoire in Paris; the 'Messiah' (1716), now in Oxford; and the 'Medici' (also 1716) in the Florence Conservatorio.

Stradivarius also made cellos, slightly altering the accepted measurements, and a few violas. He was still working with his pupils at the age of ninety-five. His finest instruments, in terms of both shape and tone, were constructed between 1710 and 1720. As a matter of interest, the number of authentic Stradivarius violins surviving at the beginning of this century was about 540 – out of more than a thousand he is known to have made. There were also twelve of his violas and fifty of his cellos.

THE CITTERN

An instrument of great popularity, and with many shapes, is the cittern or cithern. It was played during the Middle Ages and became very popular in the 16th century. The double strings of metal were plucked with the fingers or a plectrum, and attached to the top neck, on the scroll, by means of pegs placed laterally. The body was pear-shaped and the front and back were flat.

The appearance of the instrument could be varied by fretwork covering the sound-hole in the centre, or

by decorating the scroll imaginatively and ornamenting the front and ribs with inlays. The popular character of the instrument precluded any set shape and size; it varied from the smallest cittern, of four strings, to the pandore (English in origin) of six strings, and from the orpharion of eight strings to the penorcon of nine. These last were larger than the true cittern, the soundboard being often elegantly divided into lobe-shaped sections. In the 18th century these instruments began to give way to the guitar in popularity.

THE PSALTERY

The name 'psaltery' was used by the ancient Greeks, and indicated an instrument whose strings could be plucked. But in the Middle Ages it became an instrument with a simple triangular case, rounded corners and sides curving slightly inwards. Over the sounding board were stretched strings which were plucked by the fingers.

The instrument was of Eastern origin, and was in use until the 18th century or even later. It was sometimes decorated with perforations and rosettes on the sides; sometimes an outer case was even more richly decorated. Fine examples of 18th-century psalteries are to be seen in the Castello Sforzesco, Milan. They

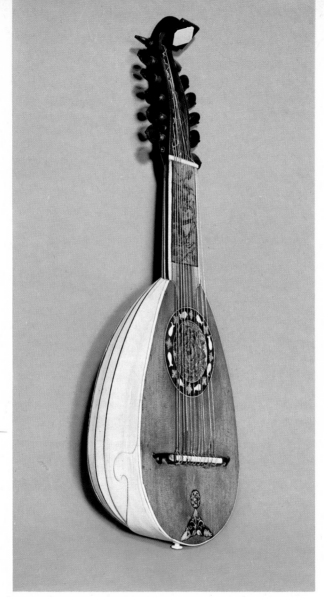

55 Small lute or mandoline by Pietro Zenatto. 1657.
Gemeentemuseum, The Hague.

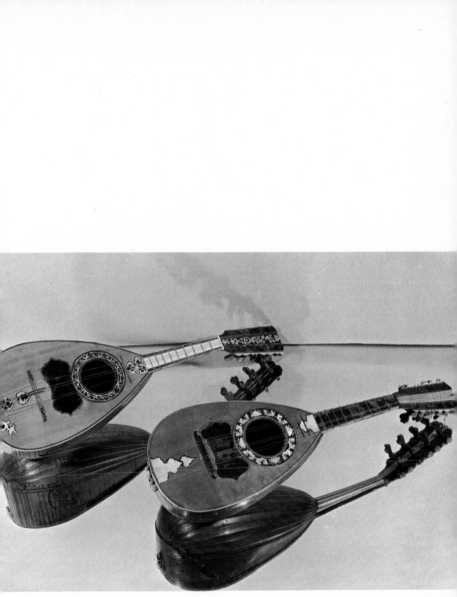

56 Neapolitan mandolines. 17th century. Conservatoire Royal de Musique, Brussels.

55 Small lute or mandoline by Pietro Zenatto, 1657. Ge-
meetemuseum, The Hague. Zenatto was a competent maker
who worked in Treviso in the 17th century. He left various
instruments, including this one similar to the Milanese mando-
line.

56 Neapolitan mandolines. 17th century. Conservatoire
Royal de Musique, Brussels. The latest arrivals in the lute
family were the mandolines, still popular today in folk-music.
Handel, Vivaldi, Mozart and Beethoven included them in their
compositions. Those of Italian construction have their own
characteristics, such as the spatulate head for the pegs, the
markedly convex case, four pairs of strings, and the tortoiseshell
plate beneath the sound-hole.

57 Milanese mandoline. 18th century. Castello Sforzesco,
Milan. This differs from the Neopolitan mandoline in having
six pairs of strings and a peg-box similar to that used in bowed
instruments. A remarkable feature of this one is the beautifully
decorated sound-hole.

58 Guitar by Mango Longo. 1624. Castello Sforzesco, Milan.
Longo was a little-known maker who was working in Padua
at the end of the 16th century. Note the decoration around the
sound-hole.

57 Milanese mandoline. 18th century. Castello Sforzesco,
Milan.

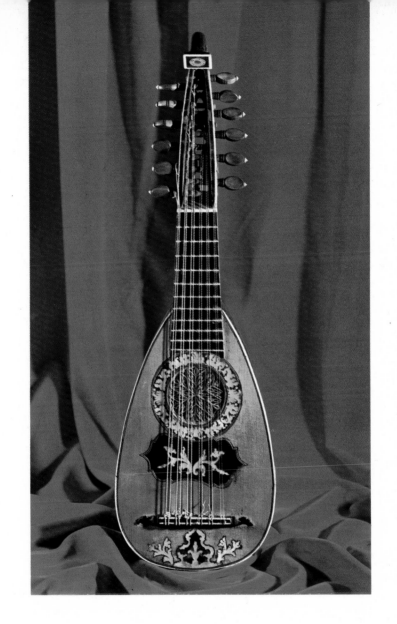

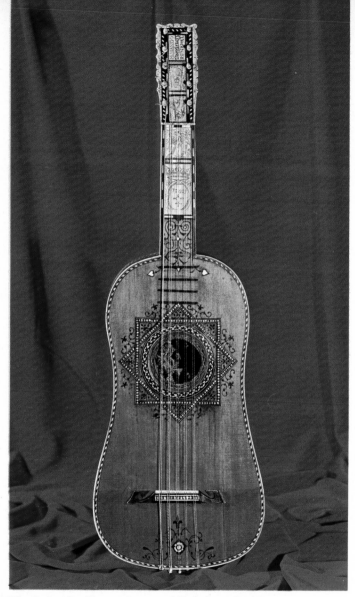

58 Guitar by Mango Longo. 1624. Castello Sforzesco, Milan.

were chiefly used by amateurs, and given the lack of any music written for them, it is unlikely that they were ever technically very remarkable. Constructed for the most part by unskilled artisans, they gave pleasure and amusement, but displayed little invention.

THE LUTE

The lute was already popular in the Middle Ages. It was introduced by the Arabs (the name itself comes from Arabic), and soon became important musically, undergoing modifications and being developed into other instruments. It soon became the first accompanying instrument for popular songs. An illustrated manuscript of the 9th century shows a French psaltery, now in the library of Utrecht University; the long neck, and the body with its big-bellied and elegantly curved back, indicate that it was an ancestor of the lute group.

The lute differs from the group of plucked instruments in the shape of its body, in its characteristic distended back constructed of wooden strips, and in the soundboard perforated in front with the soundhole, the rose. A short, broad neck is grafted on to the upper part of the case, and on the neck are transverse

frets. The head, which holds the pegs for the strings, is turned back almost at right angles to the neck. The courses of strings, usually consist of a top string, called the chanterelle, and five double courses. They were anchored at the bridge and pass over the nut, a strip of ivory or similar hard material at the point where neck and head join, to reach the tuning pegs.

The lute soon had a privileged place among musical instruments. Having no keyboard rivals, it was more manageable, and its rich tone was well suited for accompanying the voice, while the sound of the plucked strings gave it a special lyrical quality. More important, it could play several lines at once, in the polyphonic style. It was often possible to perform a polyphonic composition in which the top line came from a singer and the others from the lute. From the 16th century onwards, adaptations of polyphonic or instrumental music for the lute began to be published, just as today orchestral music is reduced for piano scores. When the fashion for the accompanied solo voice arrived, the lute became extremely important. We may assume that it was in part responsible for the decay of polyphonic music by the 17th century. Undoubtedly certain important modifications in the second half of the 16th century were made to the lute, giving it greater resonance and volume, and enabling it to serve as accompaniment.

The lute-makers, inspired by the musicians, now began to add deeper bass strings. The neck was elongated and given a second head, or a second, longer neck was constructed beside the one with the head, angled so as to lengthen the strings (which were not stopped) and produce deeper notes. In this way the family of archlutes appeared, their soundboards larger than those of lutes. Among these are the chittarone and the theorbo. The chittarone appears to be the oldest archlute; the difference between it and the theorbo lay chiefly in the length of the neck, which was straight and had two peg-boxes, a lower one for the strings sounded with the fingerboard, and one at the top for the unstopped strings. The second neck carried the other peg-box, which was set slightly to the left. A type of archlute half way between the two was the theorbo lute, a typically Italian instrument. This was a lute to which a second neck had been added, on the left, longer and straighter for the unstopped strings.

In this family of instruments, as for the bowed ones, the functional requirements of the soundboard did not allow much licence to decorators: a slight variation in shape, depending on the proportions between the soundboard and the neck, was possible, and the soundboard might have an elegant design. Decoration was therefore limited to the sound-hole, which could be perforated and carved, and to the neck, which could

be inlaid with precious woods and ivory; sometimes the back was inlaid with variegated woods. These instruments, still employing most of the techniques of the 16th century, were being used up to the middle of the 18th century, in both their small and larger forms, chiefly because of the delicate, clear notes they gave in accompanying.

GUITAR AND HARP

Much of the music written for the lute, especially that of the 16th century, was taken over for a similar instrument which became very popular in the 18th century, when the lute suffered a decline: the guitar. Its familiar figure-of-eight shape, and the long, flat neck, make this instrument unmistakable.

Its origins are uncertain, though instruments similar in appearance occur on Egyptian murals. It is known that the guitar existed and was popular among the Latin peoples early in the Christian era. In Spain the vibuela, guitar-like in shape but with many strings, was the aristocratic plucked instrument, a simple four-stringed guitar the popular one, until late in the 17th century. As the vibuela declined, the guitar, with an increased number of strings, grew in importance.

Another noble instrument in this group is the harp,

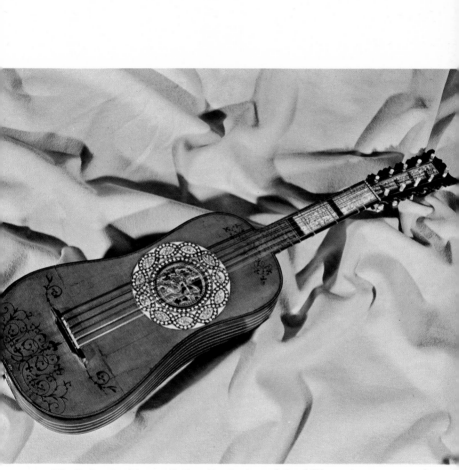

59 Guitar by Matteo Sellas. Beginning of the 17th century.
Conservatoire Royal de Musique, Brussels.

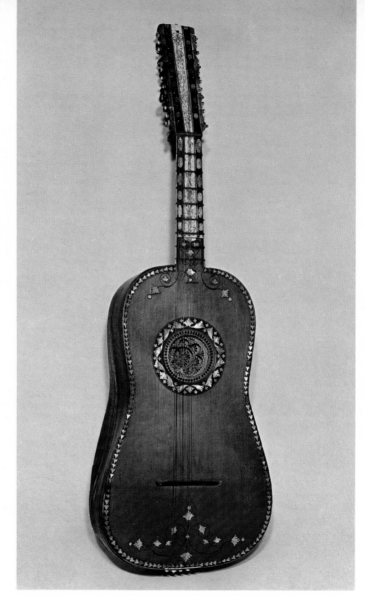

60 Italian guitar. 17th century. Gemeentemuseum, The Hague.

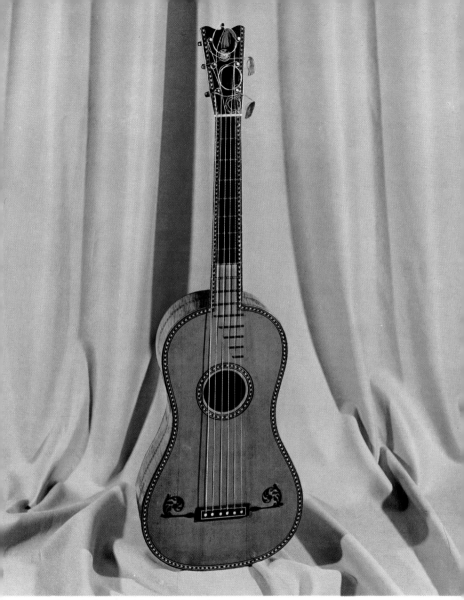

61 Guitar by Michel Mousset. End of the 18th century.
Conservatoire Royal de Musique, Brussels.

59 Guitar by Matteo Sellas. Beginning of the 17th century. Conservatoire Royal de Musique, Brussels. Recognised as one of the greatest makers of his day, Sellas worked in Venice during the first half of the 17th century. His instruments – lutes, theorbos and guitars – are notable for their fine proportions and the mother of pearl and ivory inlays.

60 Italian guitar. 17th century. Gemeentemuseum, The Hague. Another highly decorated instrument, by an unknown maker, of the sort that appealed to rich and cultured people in the 17th century.

61 Guitar by Michel Mousset. End of the 18th century. Conservatoire Royal de Musique, Brussels. The sobriety of design, emphasised by the beading round the edges, is a reflection of late 18th-century taste. We have no information about Mousset.

62 Diatonic harp. Italian. 1750. Gemeentemuseum, The Hague. The soundboard is painted with floral garlands and flying cherubs. On the base, with its four lion's paws, are three sculpted putti. The carving is elaborate on both front pillar and neck. Pedals had not yet been introduced, so the instrument was therefore tuned to the natural scale.

62 Diatonic harp. Italian 1750. Gemeentemuseum, The Hague.

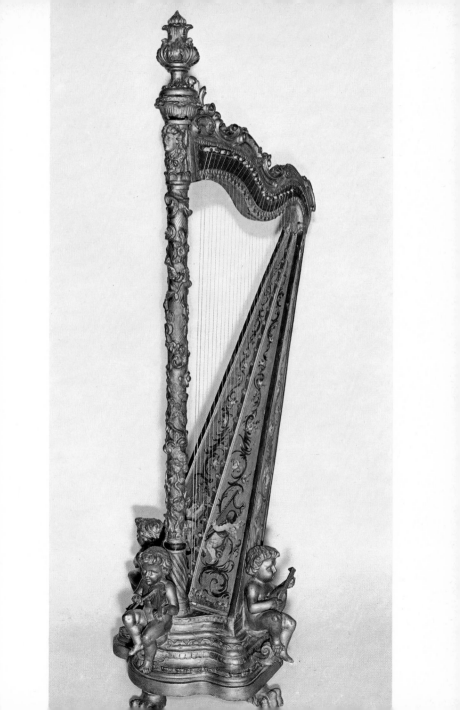

about which there is much written evidence in Egyptian and Assyrian times. It was known in 6th-century Europe and in Anglo-Saxon England and Ireland. In its earliest forms it had a soundboard at the base and a curved upper portion or neck, so that the strings could be hooked on to it.

FLUTES

The last group of instruments to be examined are those whose sound is produced by the vibration of a column of air inside a cylindrical pipe. This too forms a large family of instruments of great antiquity. It is subdivided according to the way the sound is produced by the mouthpiece.

First comes the family of the flutes, of which there are two types: the vertical, the modern representative of which is the recorder; and the transverse, the modern representative of which is the orchestral flute. In the vertical type, the sound is produced by the breath passing through the mouthpiece against a niche or lip but in the instrument. The timbre is soft and the intensity of the sound consistent. Vertical flutes were popular in the 15th century, and by the 16th had acquired their definitive shape and form, when they were used in the first instrumental ensembles along

with bowed instruments and cornetts. Though the transverse flute eventually became more important, the former still had a place in the music of the 16th and early 17th centuries, particularly in northern Europe. A theoretical work published in 1535 by the Venetian Silvastro Canassi dal Fontego, is one of the earliest works of its kind for the vertical flute. Bach stipulated the use of the vertical flute on more than one occasion.

Lighter and nimbler, the transverse flute suited the tonal and technical musical requirements of the 18th century better. The method for sound production, blowing across, and against the opposite edge of, a circular opening at the end of the flute, allowed many virtuoso effects, *piano* or *forte,* which were not possible in the vertical flute. The cylindrical form and the transverse position of the hands, situated to the right in relation to the player's lips, should be noted. In the 17th century its shape was modified into a cone; the old cylindrical form was only readopted in about 1860. Formerly constructed of wood like the vertical flute, it is now nearly always of metal. In the mid 19th century, an ingenious German flute-maker, Theobald Böhm, devised a system of levers which enabled the apertures to be opened and shut easily. This system, with a few additional improvements, has given the transverse flute a long lease of life within the orchestra, from the early 18th century to the present day.

HORN, TRUMPET AND TROMBONE

Finally, we must mention another group of instruments, well known in antiquity, which have played an important role throughout musical history. They are part of the group of aerophones, and comprise instruments with mouthpieces, the sound being produced by the lips pressed against the end of the instrument, at the funnel, known as the mouthpiece. Owing to its metallic construction, this is called the brass section, and its members are the horn, the trumpet, the trombone and a number of other instruments which differ in tone and register.

The bas-reliefs on Roman triumphal arches and columns record the simple and unmistakable form of the trumpet. At the end of the Middle Ages, trumpets were of various lengths. Contemporary nomenclature, *tubae* and *tubectae,* made a distinction between the ancestors of present-day instruments. In an almost parallel development, the trumpet and the trombone joined the ranks of the instruments in the 15th century. From that time the trumpet was curved to compensate for the length of the sounding body. Known as the clarino or clarion, it was in demand in the 17th century, and by the end of that century there was much music written specially for it. In the 19th century, valves or pistons were added to increase the

63 Harp said to have belonged to Marie-Antoinette. 18th century. Conservatoire National de Musique, Paris.

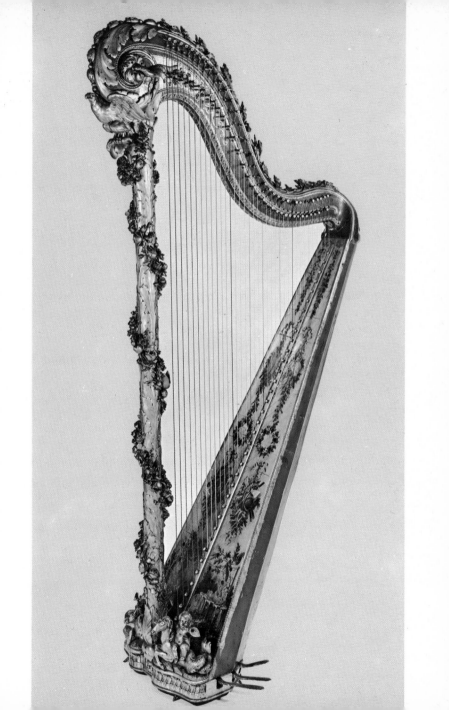

63 Harp said to have belonged to Marie-Antoinette. 18th century. Conservatoire National de Musique, Paris. This particular style, known as Louis XVI, is notable for decoration which conformed to the general lines of the instrument. A feeling of strength is given by the cambering of the neck. Note also the ornament on the soundboard, and the use of pedals.

64 Harp by Georges Cousineau. Second half of the 18th century. Castello Sforzesco, Milan. Cousineau was one of the first makers to develop the pedals (though they were perfected by a Bavarian maker in 1820); by using them the tonality could be varied. The clean functional design and mechanics of the pedals were then copied by Sébastian Erard, who later developed the harp for use in large orchestras.

65 Recorder or vertical flute by J. W. Oberländer. Second half of the 19th century. Kark-Marx-Universität, Leipzig. This instrument played an important part in instrumental music, especially in the 16th century. Precious woods of many kinds as well as ivory, were used.

66 Transverse or German flute by J. J. van Heerde. End of the 18th century. Gemeentemuseum, The Hague. In the early days of its existence this type of flute was not very popular. Partly thanks to the playing of Joachim Quantz in the 18th century, it replaced the recorder or vertical flute. This example is in ivory, with a female head as decoration; otherwise the design is extremely simple.

64 Harp by Georges Cousineau. Second half of the 18th century. Castello Sforzesco, Milan.

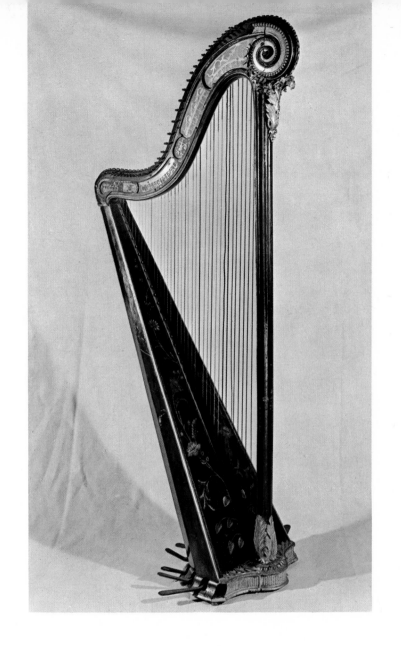

65 Recorder or vertical flute by J. W. Oberländer. Second half of the 19th century. Karl-Marx-Universität, Leipzig.

66 Transverse or German flute by J. J. van Heerde. End of the 18th century. Gemeentemuseum, The Hague.

number of fundamental notes available. A slide was soon added to a large trumpet, permitting the player to lengthen and shorten the tube and thereby obtain various notes. The trombone thus created became important from the time of the Renaissance.

In all these instruments we have seen that the functional and cylindrical form allowed little scope for decoration. The wood of the recorder or vertical flute could be carved; the parts near the trumpet mouthpiece could be decorated with metal. In the Baroque period the tube was sometimes looped in elegant designs, but usually the more simple form was preferred.

THE MODERN REVIVAL

Musical instruments have always possessed historical interest; and we have treated them in this light, though they also have aesthetic interest, since they are often beautiful in themselves, and reflect the taste and style of the period in which they were made. But naturally it is the sound of the instrument that is the real test of its quality.

In the last fifty years much research has been undertaken to reproduce instruments of the past or restore surviving instruments to something like their original

condition. This has gone hand in hand with an attempt to play music of the relatively distant past in the style of the period. This movement has been stimulated by soloists and chamber music ensembles, and in more recent times by gramophone records. Today we can hear 18th-century music on a Stradivarius, or organ music played on instruments contemporary with Bach or Frescobaldi; or Mozart played on pianofortes constructed at the end of the 18th century. The rarest surviving examples, illustrated in this book, are now in museums or private collections, sometimes in the possession of well known musicians. The musical instruments of antiquity are being appreciated again, adding to our pleasure and knowledge. They alone can explain all the subtleties in music played at any epoch in history.

Although this revival is not the main subject of the present volume, it would give the wrong impression not to mention it at all. A revolution has taken place in British school music since the revival of the recorder. Germany has been even more affected, for whole young industries have grown up there, mass-producing viols, recorders, crumhorns, rebecs and other Medieval and Renaissance instruments, many of which are exported to Britain and America.

In Britain, apart from plastic recorders, the emphasis had been more on craft-made reproductions, but all

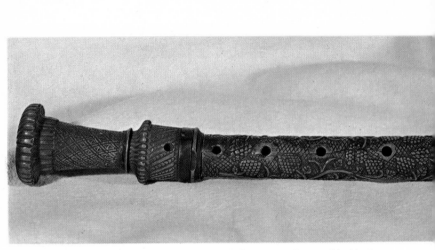

67 Recorder or vertical flute by J. Coppens. Second half of the 19th century. Conservatoire Royal de Musique, Brussels.

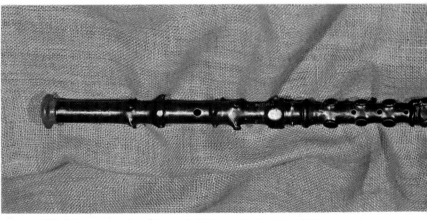

68 Transverse 'walking-stick' flute. End of the 19th century. Castello Sforzesco, Milan.

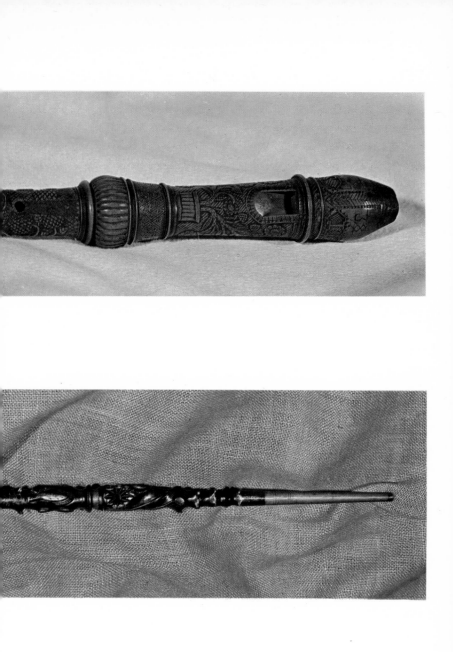

67 Recorder or vertical flute by J. Coppens. Second half of the 19th century. Conservatoire Royal de Musique, Brussels. Although the origins of this type of flute are unknown, 11th-century manuscripts refer to it. The theorist Michael Praetorius listed seven types of vertical flute in 1618, from treble to bass. The one here is the alto.

68 Transverse 'walking-stick' flute. End of the 19th century. Castello Sforzesco, Milan. This wooden flute is carved in the form of a stick, and was often used as such. In the early 19th century other dual-purpose instruments became popular: the clarinet-stick, the trombone-stick, even the violin-stick. A kind of peripatetic display of passion for music.

69 Horn by J. Leonard Ehe. Beginning of the 18th century. Conservatoire Royal de Musique, Brussels. The horn became an orchestral instrument in the second half of the 17th century. The tube was elongated, and made conical only at the end; consequently the tone became more brilliant but also more tender. From the original shape, as shown in this early 18th-century example, the horn underwent various modifications which improved it so much technically that it is now one of the most important orchestral instruments.

70 Trumpet by Johann Wilhelm Haas. Nuremberg. 1694. Conservatoire Royal de Musique, Brussels. This trumpet still possesses the decorated convoluations inherited from similar instruments of the 16th century. It was eminently suitable for the music of its time.

69 Horn by J. Leonard Ehe. Beginning of the 18th century. Conservatoire Royal de Musique, Brussels.

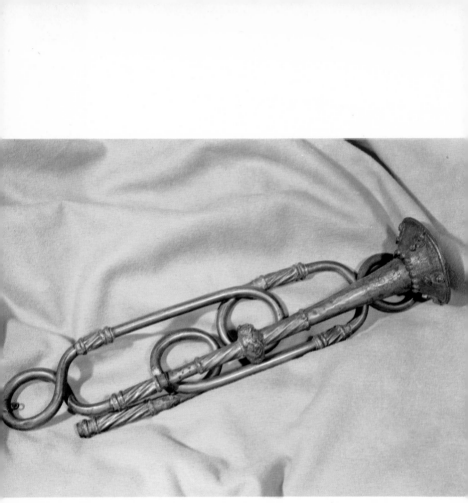

70 Trumpet by Johann Wilhelm Haas. Nuremberg. 1694.
Conservatoire Royal de Musique, Brussels.

makers are kept at full stretch with home and export orders, some harpsichords even going to Iron Curtain countries. There are several societies, such as the Dolmetsch Foundation, the Galpin Society, the Recorder Society, the Viola da Gamba Society and the Lute Society, devoted to the study of these instruments and their music, with a large and growing international membership. Other countries have similar societies, likewise flourishing. The principal music colleges now include harpsichord, recorder and viol in their syllabuses, and some hold diploma examinations in these subjects. Summer schools in this and other countries are held annually for the recorder, the viol and other instruments, the latest being the lute.

The interest in antique instruments, which first stimulated the demand for reproductions, is now itself stimulated by the actual playing experience of many hundreds of amateurs, and by ever increasing opportunities of hearing early music played on the instruments for which it was written. In the new instrument room at the Victoria and Albert Museum, it is sometimes impossible to get anywhere near the juke-box for the crowds of young people eager to hear the sounds of instruments similar to those in the cases. Clearly it is no longer possible to regard antique instruments as of purely 'antiquarian' interest.

LIST OF ILLUSTRATIONS Page

1 Organ by the Antegnati family. Third decade of the 9
17th century. S. Carlo, Brescia.
2 Organ by Domenico di Lorenzo of Lucca. 1523. SS. 10
Annunziata, Florence.
3 Organ by Giangiacomo Antegnati. 1536. Rotonda, 13
Brescia.
4 Positive organ by Gottfried Silbermann. 1724. 14
Karl-Marx-Universität, Leipzig.
5 17th-century Organ. New Cathedral, Salamanca. 19
6 Italian portative organ. 1608. Conservatoire Royal de 20
Musique, Brussels.
7 Positive organ. First half of the 18th century. Castello 21
Sforzesco, Milan
8 Positive organ by Hähnel, c.1725. Schloss Pillnitz 22
(Wasserpalais), Dresden.
9 Dutch positive organ, c.1770. Gemeentemuseum, 26
The Hague.
10 Positive organ by Diego Evans. London, 1762. 27
Múseo Municipal de Música, Barcelona.
11 Regal. Probably Italian. 1739. Múseo Municipal de 29
Música, Barcelona.
12 Bible regal organ. 18th century. Conservatoire 33
Royal de Musique, Brussels.
13-14 Harpsichord by Vito Trasuntino. 1571. 34-35
Castello Sforzesco, Milan.
15 Two-manual harpsichord by Hans Ruckers. 1612. 37
Conservatoire Royal de Musique, Brussels.
16 Single-manual harpsichord by Giovanni de'Perticis. 42
Florentine. 1672. Gemeentemuseum, The Hague.
17 Two-manual harpsichord by Hieronymus Albrecht 43
Hass. 1734. Conservatoire Royal de Musique, Brussels.
18 Single-manual harpsichord by Antonio Scotti. 45
Milan. 1753. Castello Sforzesco, Milan.
19 Two-manual harpsichord by Piero Todino. 1675. 46
Castello Sforzesco, Milan.

20 Upright harpsichord by Albert de Lin. Mid 18th **51**
century. Gemeentemuseum, The Hague.
21, 22 Spinet by Bedetto Floriani. 1562. Castello **52**-**53**
Sforzesco, Milan.
23 Spinet. 18th century. Castello Sforzesco, Milan. **54**
24 Virginals by Gabriel Townsend. 1641. Conservatoire **58**
Royal de Musique, Brussels.
25 French spinet. 18th century. Conservatoire National **59**
de Musique, Paris.
26 Spinet by Francesco Battaglia. 1735. Castello **61**
Sforzesco, Milan.
27 Flemish clavichord. 17th century. Conservatoire **66**-**67**
Royal de Musique, Brussels.
28 Clavichord by Hieronymus Albrecht Hass. 1744. **68**
Conservatoire Royal de Musique, Brussels.
29 Viennese pianoforte. 19th century. Castello **69**
Sforzesco, Milan.
30 Upright pianoforte by Friederici di Gera. 1745. **70**
Conservatoire Royal de Musique, Brussels.
31 Square pianoforte by Muzio Clementi, _c._1810. **74**
Conservatoire Royal de Musique, Brussels.
32 Psaltery with case. Late 17th century. Castello **75**
Sforzesco, Milan.
33 French harp. 17th century. Conservatoire Royal de **77**
Musique, Brussels.
34 Hurdy-gurdy. 1768. Musée des Arts Décoratifs, **78**
Paris.
35 Hurdy-gurdy by César Pons. 1770. Conservatoire **83**
Royal de Musique, Brussels.
36 Treble viol by Heinrich Ebert. Second half of the **85**
17th century. Conservatoire Royal de Musique,
Brussels.
37 Viola da gamba by Joseph Stoss, 1718. Wagner **86**
Museum, Lucerne.
38 Instrument dating from the 18th century. Castello **87**
Sforzesco, Milan.
39 Violin by Antonio Stradivarius. 1671. Castello **91**
Sforzesco, Milan.

40 Violin by Andrea Guarneri. 1694. Castello Sforzesco, **92**
Milan.
41 Violin by Kaspar Duiffoprugcar (Tieffenbrucker). **93**
Mid 16th century. Castello Sforzesco, Milan.
42 Viola by Jacob Stainer. 17th century. Castello **95**
Sforzesco, Milan.
43 Viola d'amore by Kaspar Stadler. 1714. **99**
Germanisches Nationalmuseum, Nuremberg.
44 Lower portion of a viol by Joachim Tielke. 1701. **100**
Conservatoire Royal de Musique, Brussels.
45 Kits. 18th century. Conservatoire Royal de **101**
Musique, Brussels.
46 Cittern. 17th century. Conservatoire Royal de **103**
Musique, Brussels.
47 English keyed cittern by Longman and Broderip. **107**
End of the 18th century. Conservatoire Royal de
Musique, Brussels.
48 Lute by Giovanni Hieber. Second half of the 16th **109**
century. Conservatoire Royal de Musique, Brussels.
49 Penorcon. 17th century. Conservatoire Royal de **110**
Musique, Brussels.
50 Soprano lute. 18th century. Castello Sforzesco, **111**
Milan.
51 Chittarone by Magnus Duiffoprugcar (Tieffen- **115**
brucker). Venice. 1593. Castello Sforzesco, Milan.
52 Chittarone. 16th century. Gemeentemuseum, The **116**
Hague.
53 Theorbo lute by Magnus Duiffoprugcar (Tieffen- **117**
brucker). 1610. Wagner Museum, Lucerne.
54 Colascione. Beginning of the 17th century. **119**
Gemeentemuseum, The Hague.
55 Small lute or mandoline by Pietro Zenatto. 1657. **124**
Gemeentemuseum, The Hague.
56 Neapolitan mandolines. 17th century. Conservatoire **125**
Royal de Musique, Brussels.
57 Milanese mandoline. 18th century. Castello **127**
Sforzesco, Milan.

58 Guitar by Mango Longo. 1624. Castello Sforzesco, **128** Milan.

59 Guitar by Matteo Sellas. Beginning of the 17th **133** century. Conservatoire Royal de Musique, Brussels.

60 Italian guitar. 17th century. Gemeentemuseum, The **134** Hague.

61 Guitar by Michel Mousset. End of the 18th century. **135** Conservatoire Royal de Musique, Brussels.

62 Diatonic harp. Italian 1759. Gemeentemuseum, The **137** Hague.

63 Harp said to have belonged to Marie-Antoinette. **141** 18th century. Conservatoire National de Musique, Paris.

64 Harp by Georges Cousineau. Second half of the **143** 18th century. Castello Sforzesco, Milan.

65 Recorder of vertical flute by J. W. Oberlander. **144** Second half of the 19th century. Karl-Marx-Universität, Leipzig.

66 Transverse or German flute by J. J. van Heerde. End **145** of the 18th century. Gemeentemuseum, The Hague.

67 Recorder or vertical flute by J. Coppens. **148-149** Second half of the 19th century. Conservatoire Royal de Musique, Brussels.

68 Transverse 'walking-stick' flute. End of the **148-149** 19th century. Castello Sforzesco, Milan.

69 Horn by J. Leonard Ehe. Beginning of the 18th century. Conservatoire Royal de Musique, Brussels. **151**

70 Trumpet by Johann Wilhelm Haas. Nuremberg. **152** 1694. Conservatoire Royal de Musique, Brussels.